D1433290

THE
GRAFFITI
FILE

THE GRAFFITI FILE

NIGEL REES

London

GEORGE ALLEN & UNWIN

Boston Sydney

Graffiti Lives, OK first published in Great Britain
by Unwin Paperbacks 1979

Graffiti 2 first published in Great Britain
by Unwin Paperbacks 1980

Graffiti 3 first published in Great Britain
by Unwin Paperbacks 1981

This collection first published in one volume
by George Allen & Unwin 1981
Reprinted 1981, 1982, 1983

George Allen & Unwin (Publishers) Ltd,
40 Museum Street, London WC1A 1LU, UK

George Allen & Unwin (Publishers) Ltd,
Park Lane, Hemel Hempstead, Herts HP2 4TE, UK

George Allen & Unwin Australia Pty Ltd,
8 Napier Street, North Sydney, NSW 2060, Australia

The Graffiti File is based on the three paperbacks designed by
David Pocknell's Company Limited.

British Library Cataloguing in Publication Data

Rees, Nigel
 The graffiti file.
1. Graffiti
I. Title
828'.02 GT3912

ISBN 0-04-827049-0

Printed in Great Britain by Butler & Tanner Ltd,
Frome and London

We may not all write graffiti, but almost all of us have occasion to see it from time to time. Whether we derive amusement from what we contemplate depends as much on ourselves as on the nature of the messages. The mindless stuff of gang graffiti, football slogans and name-tags can be a bore to read. But some graffiti actually try and *say* something – if only to raise a laugh. And the way they arise and circulate as elements of popular folklore is just as fascinating as the way in which quotations, catchphrases and slogans are used in everyday speech.

The Graffiti File brings together over one thousand sharp, scatty and sexy comments from the walls of the world, as they have previously been recorded in three separate volumes – *Graffiti Lives, OK, Graffiti 2* and *Graffiti 3*. Although some of the graffiti included in this collection have been around for as long as fifty years and show no sign of disappearing, there is a sense in which all graffiti are constantly in danger of being obliterated. **The Graffiti File** aims to give them a measure of permanence.

The peculiar, anonymous nature of graffiti's creation and dissemination means that it is impossible to say for sure why they get written or who writes them. However, a kind of picture does emerge through an evaluation of sightings by diligent graffiti-spotters.

With the funnier and wittier scrawls there is a lot in common between writing graffiti and telling jokes. Perhaps the graffiti-writer is a shy joke-teller. He 'tells' his joke on a wall and runs away without waiting for a response.

The best graffiti, however, convey a type of humour you do not find in quite the same form anywhere else, least of all spoken. What often generates it is an element of protest or

frustration – at official bossiness, at the cocksure claims of advertisers, and at the unremitting exercise of Sod's Law in every area of human existence. But behind it there is an – often good-humoured – acceptance of the fact that you cannot change anything and that writing on a wall is the only way left to vent your feeling.

Among theories applying to graffiti-writers, it has been suggested that such people are 'non-rugged individualists' because they make their point without much fear of any comeback; that they are like space scientists who send out probes filled with souvenirs and artefacts depicting human culture, saying in effect 'I am here, I exist'; and, that they are marking out their territory, fortunately not using the animal method of doing so.

The 'marking out of territory' and 'I am here, I exist' reasons for graffiti-writing probably apply more to the writing of names and initials than to the more imaginative work with which **The Graffiti File** is concerned. The former type is particularly prevalent in New York, where the writing of signatures or 'tags' in colourful ways, mostly on subway trains, has reached epidemic proportions and costs the transit authority millions of dollars a year to remove.

As long as there has been writing on the wall there have been people wanting to remove it. In Thomas Hardy's *Return of the Native* (describing a rural area in the mid-Nineteenth Century) we read: 'Ah, there's too much of that sending to school these days! It only does harm. Every gatepost and barn's door you come to is sure to have some bad word or other chalked upon it by young rascals: a woman can hardly pass for shame sometimes . . .'

Indeed, when the 1870 Education Act was

being debated it was suggested that extending educational opportunities to younger children would only result in more graffiti, written *lower down.*

By collecting graffiti in books and by drawing attention to them in my BBC Radio programme *Quote …Unquote,* I lay myself open to some criticism. 'As the practice of scrawling graffiti is only a brand of the vandalism which our society should be doing far more to discourage and eliminate,' wrote one correspondent, 'I implore you not to quote any of it, however witty and amusing it may seem. Surely, the method by which it is expressed, i.e. by defacing public or private property, immediately cancels out its rare cleverness. And to quote such wit will but serve to encourage the idiots (be they clever or simple) who practise it.'

A valid argument. No one with any sense wishes to encourage moronic, ugly graffiti or the disfigurement of buildings. But I suspect that most people would be willing to tolerate a certain amount of graffiti if they provide amusement and brighten up dull stretches of brick and concrete.

Besides, it is unlikely that the urge to write on walls will ever be eliminated, so the best that can be done is to contain it. In other words, let graffiti be written where they can easily be removed, where they do not blot the landscape – and let the graffiti be good ones.

No one, to my knowledge, has ever been fined or imprisoned for writing amusing graffiti, only for the other sort. But it is an offence in most countries and a particularly bad place to get caught is Singapore. There you can be fined up to 2,000 dollars or sent to gaol for three years, in either case laying yourself open to

between three and eight strokes of the cane.

The urge is universal. Although the majority of examples quoted in this volume come from walls in the United Kingdom, there are also contributions from the United States, Canada, Australia and one or two other countries. One place that is somewhat under-represented is the Soviet Union. There you may face a ten-year gaol sentence for defacing property if you get caught. It is also said that nobody could bear to stay long enough in a Soviet public lavatory to write anything on the walls ...

The writing of humorous comment seems, however, to be chiefly a pre-occupation wherever the English language is spoken. In other languages graffiti-writers are mostly obsessed with glum political sloganeering or simply with sexual hieroglyphics. But within the English-speaking world the same graffiti recur from region to region, from country to country. Clearly, local personalities and happenings will attract comment from graffiti-writers. Sometimes this will be expressed in a way peculiar to the area.

Hence, for example, the series of scribblings recorded in this book upon the theme 'so-and-so rules, OK'. As straight boasts, these probably began as gang slogans in Scotland and Northern Ireland in the late 1960s – as in 'Provo Rule, OK', in support of the Provisional IRA. During the mid-1970s the form was taken up by clever folk who dreamt up numerous jokes upon the theme.

Another long-running graffiti-form in the UK is based on the advertising phrase, 'I thought so-and-so, until I discovered so-and-so ...' This was given a boost in 1975 when Smirnoff vodka ran a poster campaign which showed a graffito

on a wall saying, 'I thought St Tropez was a Spanish monk until I discovered Smirnoff'. This, too, gave rise to many variations.

The slogan, 'Heineken refreshes the parts other beers cannot reach' has likewise proved irresistible to graffiti-writers.

It is unlikely that any one reader will understand all the references contained in **The Graffiti File**. The compiler certainly does not claim to, enjoying the almost wilful obscurity of some examples.

What unites almost everything in the book is a kind of spirit. Graffiti patterns and graffiti jokes travel about the world with the speed of light, leaping over national boundaries, and often obscuring their origins. Basic jokes are subjected to new twists, which is why one or two recur from time to time throughout these pages.

It is fair to say that graffiti are probably much wittier than they were two decades ago. Thanks to the introduction of felt-tipped pens and paint in aerosol cans, writing on walls is not the laborious activity it once was. (In Pompeii, after all, the Romans had to *scratch* what they wanted to say – hence our used of the word 'graffiti' which is Italian for 'scratchings'.) As a result, graffiti are no longer the preoccupation of morons, with or without a message.

Researching the difference between men's and women's graffiti presents certain difficulties of attribution and access. However, women seem to have a tendency to write lengthier graffiti and to be even more concerned with sex. A recent British survey showed that women had written three times as much graffiti as men, though this was largely because they went in for long paragraphs, where for men a sentence would do. This finding compares with Alfred C. Kinsey's

investigations into American sexual *mores* in the late 1940s. His conclusion was that relatively few women wrote things on walls and, when they did, only 25 per cent of the material was erotic in content (compared with 86 per cent for men).

Feminists are keen to point out that one reason for the general absence of humour in female graffiti is that a woman's lot is still not a happy one. The Women's Movement of the 1970s, far from coming out of the closet, in one sense retreated into it, and used the wall as a serious vehicle for the expression of views.

I have been helped by countless people in compiling this book. Where a place name follows an example, that merely indicates a sighting reported to me. The graffito may well occur elsewhere and almost certainly does. I have marked some of the hoarier ones as 'traditional'. When a graffito has been added to an advertisement or, indeed, to an already-existing graffito, the addition is printed after a dash. Also, I have supplied dates where this might help point up a reference.

To the graffiti-spotters, my thanks are due. To the countless, anonymous graffiti-writers, this book is dedicated.

The moving spray can writes;
and, having writ, moves on. Nor
all thy piety nor Wit shall lure it
back to cancel half a line, nor all
thy Tears wash out a Word of it.

Really the writer doesn't want
success ... He knows he has a
short span of life, that the day
will come when he must pass
through the wall of oblivion,
and he wants to leave a scratch
on that wall – Kilroy was here –
that somebody a hundred, or a
thousand years later will see.

William Faulkner

Prepare to meet thy God.
(Evening dress optional)

bridge on the A1

The grass is always greener
on the other fellow's grave.

*Lewisham
cemetery*

Get the Abbey habit – go to
bed with a monk.

London W1

Be alert. Your country needs
lerts.

I'd give my right arm to be
ambidextrous.

*Hemel
Hempstead*

Last Tuesday's meeting of the
Apathy Society has just been
cancelled.

North London

GRAFFITI

My dad says they don't work.

*written on
contraceptive
vending machine*

I thought UDI was a contraceptive until I discovered Ian Smith.

Oxford

During the Second World War a very patriotic little character called 'Billy Brown of London Town' was devised by London Transport to exhort the public. Concerning anti-splinter netting on Tube trains 'the world's most exemplary passenger' said:
'In the train a fellow sits and pulls the window-net to bits because the view is somewhat dim, a fact which seems to worry him. As Billy cannot bear the sight, he says, "My man, that is not right! I trust you'll pardon my correction: That stuff is there for your protection."'

Underneath was commonly added, in pencil:

I thank you for your information, but I can't see the bloody station.

13

IF BATMAN
IS SO SMART
WHY DOES
HE WEAR
HIS
UNDERPANTS
OUTSIDE HIS
TROUSERS?

Bill Stickers Will Be
Prosecuted. – Bill Stickers is
innocent.

trad.

Bill Stickers is innocent, OK

Pimlico

In 1975
George Davis was given a
17-year prison sentence for
taking part in a robbery and
wounding with intent to avoid
arrest. Those who believed in his
innocence wrote the slogan

GEORGE DAVIS IS INNOCENT, OK

all over the East End of
London. The campaign was
taken up elsewhere and in May
1976 Davis was released from
prison but not pardoned. In
July 1978 he was sentenced to
15 years gaol for his part in a
subsequent bank robbery.

Free George Davis.
(to which was added:)
With every packet of
cornflakes.

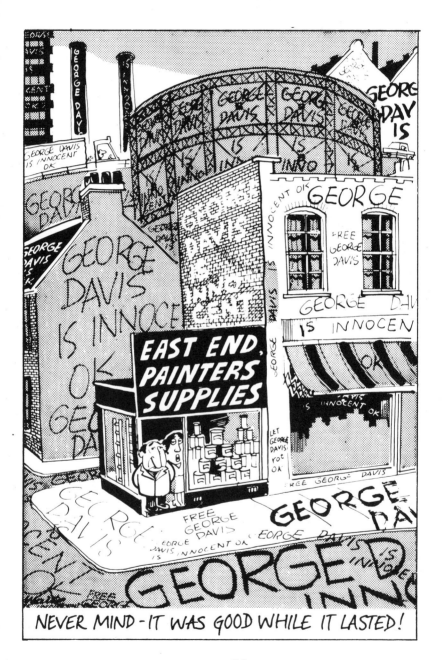

NEVER MIND - IT WAS GOOD WHILE IT LASTED!

Life is just a bowl of toenails.

Oxford

God is not dead, but alive and well and working on a much less ambitious project.

Jesus wepped.

At the advertising agency which lost the Schweppes account.

Do not feed the animals. They are dead.

Smithfield Market

N.F.

– No Fun.
– No Freedom.
– No future.

Je suis Marxiste – tendance Groucho.

Paris, May 1968

I thought clap was a form of applause until I discovered Smirnoff.

AGRO.

> *written high up on a wall in large letters. Near the bottom in another hand:*

I wish I did.

> *Sankey, near Warrington*

Smile! You are now on Candid Camera.

> *lavatory door, Stokesay Castle*

*T*his is the worst chewing gum I have ever tasted.

> *on contraceptive vending machine*

Buy Blitish.

*on the wall of a
Datsun
distributor*

Attachons nos ceintures.

*French seat-belt
slogan, to which
is added:*

Et tirons nos braguettes.*

Toulouse

Down with early Byzantine
church music.

Cambridge

This wall has been designated
MS Bodl. 10000 and will
shortly be taken away for
binding.

*on graffiti-
covered wall in
the Bodleian
Library, Oxford.*

*flies

19

*I*f the cap fits, wear it.

ladies' lavatory

*W*ritten in a cultivated hand, using fountain-pen, on railway station timetable:

Please help smash Capitalism

*C*elibacy is not an inherited characteristic.

*D*rink wet cement and get really stoned.

Leeds University

*D*o not pull the chain. The English need the water.

Rhayader,
Wales

Christ did not say 'Kill Trees for Christmas'.

Edinburgh

It's no good looking for a joke. You've got one in your hand.

Gents, Taunton

Christine. If you're reading this, we're through.

Gents,
Bermondsey

ACID FREES THE MIND
(later modified to :)
ACID FRIES THE MIND

Harrow

A poster for the film *Young Winston* showed Churchill standing over a heap of dead Indians. Someone had drawn a speech balloon coming out of his mouth, saying :

And now for those bloody Welsh miners.

GRAFFITI

Clean air smells funny.

Clunk, click, every trip.

> *On museum
> chastity-belt
> exhibit*

Richard Coeur de Lion – first
heart transplant?

> *Mold*

Does the lateral coital position
mean having a bit on the side?

The grave of Karl Marx is just
another Communist plot.

> *Charing Cross
> Road*

God is dead. Nietszche.

– Nietsche is dead. God.

*H*arwich for the Continent

– Frinton for the incontinent.

Colchester
station

*I*n a Gents at the University of
Glasgow was a vertical line of
arrows pointing upwards. You
followed the arrows up the wall
and at the very top were a
couple of lines of text in small
writing. The only way to read
them was to stand on the
lavatory. Then you could read:

*I*t's no use standing on the seat,
The crabs in here can jump
ten feet.

*J*esus Saves.
With the Woolwich.

Wandsworth

*T*he upper crust are just a lot
of crumbs sticking together.

Newcastle
University

*C*unnilingus is not an Irish
airline.

trad

On behalf of the Melbourne University Graffiti Writers Club we would like to welcome you. We hope you have an enjoyable and educational experience.

Keep things as they are. Vote for the Sado-Masochist Party.

Swiss Cottage

Rupert Murdoch was here and will be back with a stock option.

Overseas Press Club, New York

You don't buy beer, you rent it.

Safeguard your health. Don't sleep with any damp women.

Einstein rules relatively, OK

AMNESIA RULES, O...

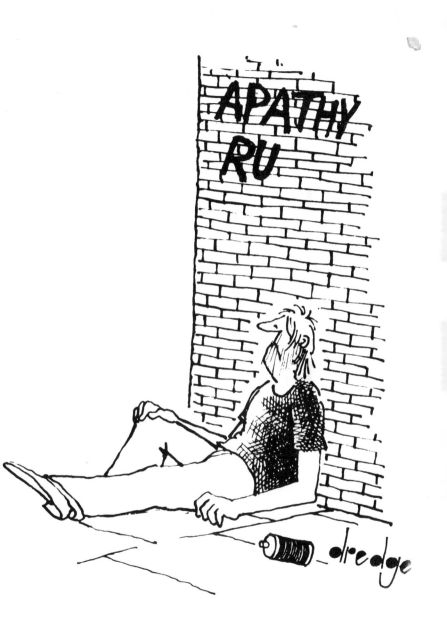

*N*ew shape! New sensitivity!

> *advert for*
> *condoms, to*
> *which has been*
> *added:*

*B*ut the same old feeling.

*C*olin Davis can't tell his
brass from his oboe.

> *Royal Festival*
> *Hall*

*W*here will you be on the Day
of Judgement?

> *church poster,*
> *South-East*
> *London, to which*
> *was added:*

*S*till here, waiting for a No.95
bus.

*S*exual intercourse after death.
Is this what is meant by getting
laid in your grave?

*D*eath is nature's way of telling
you to slow down.

*G*oodnight David

*G*oodnight Goliath!

*H*ave you seen the film *Deep Thought*? It's about a Girtonian whose clitoris was all in her mind.

Cambridge

*E*ven dirty old men need loving.

Gents,
Bermondsey

*T*o do is to be – Rousseau.

To be is to do – Sartre.

Dobedobedo – Sinatra.

*A*bstinence is the thin end of the pledge.

I drink therefore I am.
I'm drunk therefore I was.

Ruislip

*M*ake Love Not War.
(See driver for details.)

written in road
grime on back of
a large van

VOTE FOR DUFFY.
(And Ireland's dead will rise
up and curse you.)

> *addition to
> election poster,
> Dublin, 1925*

Six-inch Chinese dwarf wishes
to meet person with similar
interests.

> *written five feet
> up a wall in the
> Bodleian
> Library, Oxford.
> Underneath was
> written:*

PS This took considerable
effort.

Dwelling unit sweet dwelling
unit.

> *Notting Hill*

Don't let them cut hire
education.

> *Camberwell
> school,
> 1977*

*E*ducation kills by degrees.

Bermondsey

*T*S Eliot is an anagram
of toilets.

*Leicester
University*

*C*onserve energy – make love
more slowly.

*N*ot for sale during the French
postal strike.

*contraceptive
vending machine*

*O*ne would think to read all
this wit
That Shakespeare himself
came here to shit.

trad

*W*omen like the simpler
things in life – like men.

*Ladies, Chorlton-
cum-Hardy*

I've told you for the fifty-
thousandth time, stop
exaggerating.

> *Imperial College,*
> *London*

*D*on't throw your fag ends
in the loo,
You know it isn't right.
It makes them very soggy
And impossible to light.

> *trad*

*M*odern fairy story:
And they lived happily ever
after someone else.

> *Birmingham*

I'm a fairy. My name is Nuff.

Fairynuff.

*T*his is not a contraceptive
machine.

> *written on cold*
> *water tank,*
> *Headingley*

31

*F*ar away is close at hand in images of elsewhere.

> *This poetic graffito (echoing 'Song of Contrariety' by Robert Graves) appeared in large letters just outside Paddington Station. 'Peter Simple',* the Daily Telegraph *columnist, attributed them to 'The Master of Paddington', a genius of the brush also said to have daubed:*

WE ARE THE WRITING ON YOUR WALL

*A*n advertisement for the film *Earthquake* had the bottom stroke of the first 'E' removed and the 'H' painted out and thus read:

FART QUAKE – an earth-shattering experience.

Newton Abbot

Tomorrow will be an action-replay.

*North
Kensington*

Lecture this evening on
schizophrenia. (to which has
been added:)
I've half a mind to go. (and
the further comment:)\
I'm in two minds also.

GOD BLESS

ATHEISM.

The future is female.

– Unreliable, full of broken
promises, pretty to look at, but
horrible to face.

Cambridge

Written at top of urinal wall:

If you can aim this far you
should be in the fire brigade.

Stockport

Archduke Franz Ferdinand found alive. First World War a mistake.

To a notice saying:

NO ACCESS

is added the advice:

Use Barclaycard instead.

Birmingham

Notice on country footpath:

FREE ACCESS.

Added underneath:

Until the bull charges.

Work for the Lord. The pay is terrible but the fringe benefits are out of this world.

lavatory at Anglican theological college

Dyslexia lures, KO

Back in a minute – Godot.

Dept. of English,
Columbia
University,
New York

Don't vote. The Government will get in.

Oxford

An excellent quaffer called Rafferty
Went into a Gentlemen's lafferty.
The walls caught his sight,
Quoth he: 'Newton was right.
I'm now in the centre of Grafferty!'

London N8

Alas, poor Yorlik, I knew him backwards.

Leicester

Down with gravity.

Battersea

*I*l fait froid.

To which someone had added:

Clement weather?

Aberdeen

ASTIGMATIS

Queen Elizabeth rules UK

Fighting for peace is like fucking for virginity.

Covent Garden

Written below the light switch in a lavatory:

A light to lighten the genitals.

Oxford

*I*n one train lavatory, having complied with the injunction 'Gentlemen lift the seat', you found:

Not you Momma, sit down.*

*written in letters
five feet tall*

*R*oad sign in Lincolnshire:

**TO MAVIS ENDERBY
AND OLD BOLINGBROKE.**

Someone has added:

The gift of a son.

Catchphrase from wartime radio series Hi Gang.

GRAFFITI

I love grils.
(which was corrected thus:)

You mean girls, stupid!
(but then:)

What about us grils?

*H*ANDEL'S ORGAN
WORKS

(Notice in music library)

So does mine.

*T*he future of Scotland is in
your hands.

> *urinal wall,*
> *St Andrews*
> *University*

A happy Christmas to all our
readers.

> *on graffiti-strewn*
> *wall, Tenterden*

*J*oin the Hernia Society. It
needs your support.

> *Leeds University*

*F*ree the Heinz 57.

*B*EANZ MEANZ FARTZ

*D*eans means feinz.

> *New College,*
> *Oxford*

I thought Home was an ex-
Prime Minister until I
discovered squatting.

*H*OME RULE FOR WALES
– And Moby Dick for King.

*M*y mother made me a
homosexual.
(to which had been added:)
If I give her the wool, will
she make me one?

> *trad.*

*H*umpty Dumpty was pushed.

*J*oin the army, meet interesting people, and kill them.

Bromley

*F*REE WALES.
– Who from? What for?

*South
Glamorgan*

*C*an you beat my total of 71 men – If you supply the whips.

*S*omeone somewhere wants a letter from you.

*contraceptive
vending machine*

I wish I were what I was when I wished I were what I am.

*Ladies,
Tonbridge*

*I*s there any intelligent life on earth? – No. I'm only visiting.

Buggery is boring.
Incest is relatively boring.
Necrophilia is dead boring.

Maidenhead

God was a woman.
– Until she changed her mind.

If I could choose the place
where I die it would be London
because then the transition
from life to death would hardly
be noticeable.

Hammersmith

IVER 1.
(Road-sign, amended to:)

IVER big 1.

Support Women's Lib. Make
him sleep in the wet patch.

Advertisement at bus-stop in
Streatham Vale:
It's 85° in Jamaica right now.
What are you waiting for?

– Any bus to Brixton.

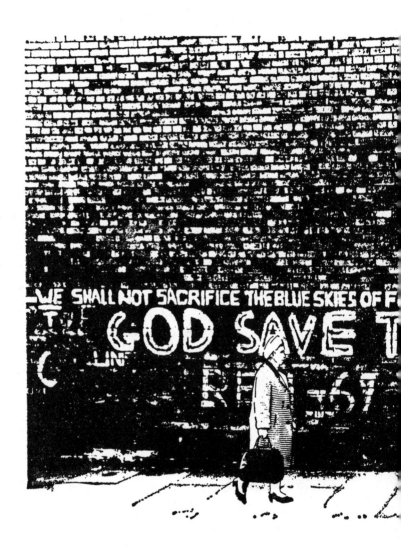

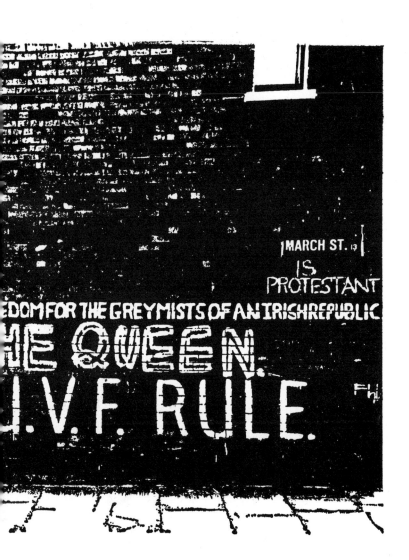

MARCH ST. 13

IS
PROTESTANT

EDOM FOR THE GREY MISTS OF AN IRISH REPUBLIC.

HE QUEEN.

U.V.F. RULE.

Jesus said to them, 'Who do you say that I am?' They replied, 'You are the eschatological manifestation of the ground of our being, the kerygma of which we find the ultimate meaning in our interpersonal relationships.' And Jesus said, 'What?'

St John's
University,
New York

Passengers are requested not to use the toilet whilst the train is standing at a station.

oxept at Aldershot

trad.

Another exhortation from the 'world's most exemplary passenger', Billy Brown of London town:

Face the driver, raise your hand – You'll find that he will understand.

Someone had added:

Yes, he'll understand, the cuss, but will he stop the blasted buss?

*I*s there nobody queer in Kirkudbright?

*M*arghanita Laski was a Bunny Girl.

London, W1

*I*n People's China the workers take the lead. (to which was added:)
In capitalist England, the sods also take the iron, copper, floorboards and fillings from your teeth.

Euston Station

*H*omes before offices.
People before cars.
– Leg before wicket.

Oxford

*1*00,000 lemmings can't be wrong.

Balliol College, Oxford.

1

2

M^cLACHLAN

3

*B*rian loves Jonathan.
– So did David. Read your
Bible.

Reigate

*I*f God wanted to give the
world an enema he'd stick the
tube in Benidorm.

Tavistock

*K*entucky Freud Chicken.
Mother-fuckin' good.

Camden

*C*uts out oven doubt.

*contraceptive
vending machine*

GRAFFITI

Dr Kissinger should be bloody
well hung.
– He is, he is.
(signed) Mrs Kissinger.

Bolton

*B*alliol wall is the people's
organ. Contributions welcome.

*I*s there a life before death?

cemetery wall,
Ballymurphy,
Northern Ireland

*N*orthern Ireland has a problem
for every solution.

*W*ritten above the gap at the
bottom of a lavatory door:
Beware limbo dancers!

trad.

*W*ritten high up on the wall
above a urinal in Chatham:
What are you looking up here
for? Are you ashamed of it?

*L*lantrisant.

– the hole with the Mint in it.

road-sign

50

*H*eisenberg probably rules,
OK*

*S*aliva drools, OK

> *Tonbridge*

*O*n a Norfolk village poster
advertising a talk on 'What to
do if you are going bald',
someone had pencilled:
Prepare to meet thy dome.

*Y*ou're never alone with
schizophrenia.

> *Service area,*
> *M6 motorway*

*M*ake love not war.
– Amo, amas, amat it again.

> *Victoria Station*

**Werner Karl Heisenberg was the
German physicist who proposed the
uncertainty principle (1927).
(I think – Ed.)*

British Airways poster:
– Breakfast in London.
– Lunch in New York.
– Luggage in Bermuda.

Give masochists a fair crack
of the whip.

Masturbation is habit-forming
(to which has been added,
in another weary hand:)
Now he tells us.

*Richmond,
Surrey*

God is not dead. He just
couldn't find a place to park.

Matriculation makes you deaf

Oxford

And the meek shall inherit the
earth – if that's all right with
the rest of you.

Sunderland

*T*he best laid plans of mice
and men are filed away
somewhere.

Whitehall

*J*esus saves.
– Save yourself. Jesus is tired.

*M*ilitary intelligence is a
contradiction in terms.

*Ministry of
Defence building,
London (briefly)*

*"He was great in his day, of course, but he hasn't
produced anything new for years."*

Do you have trouble in making
up your mind? – Well, yes
and no.

Bristol

How happy is the moron
He doesn't give a damn.
I wish I were a moron,
My God, perhaps I am!

service area,
M1 motorway

The British Nazi Party is a
National Affront.

Blow your mind – smoke
dynamite.

Go Gay – it's cheaper.

contraceptive
vending machine

Free Wales.
– With every five gallons.

Pontllanfraith,
Gwent

*T*his cubicle will self-destruct
in ten seconds which will make
your mission impossible.

rest room,
US airbase,
West Germany

*N*icholas Parsons is the
neo-opiate of the people.

Harrow

*M*ary Jones of 2, The High
Street does it. – So does her
mother.

South Wales

*N*ostalgia is all right but not
what it used to be. – Don't
worry, it will be one day.

Cardiff
University

*N*othing to do here.
And no one to do it to.

Bexhill-on-Sea

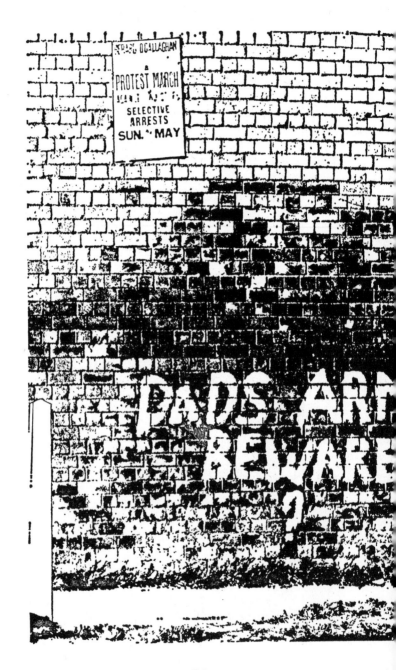

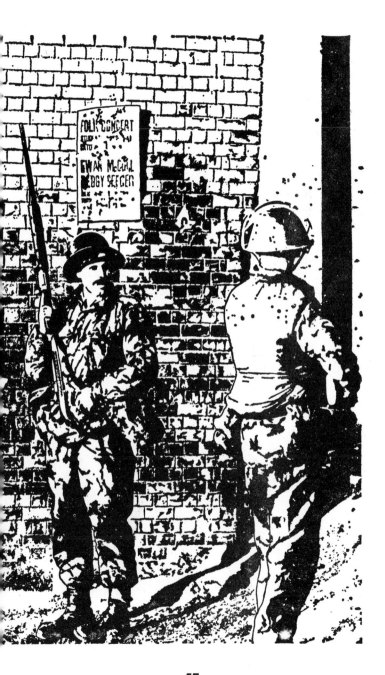

Necrophilia lives.

O.O.A.Q.I.C.
1.8.2.Q.B.4.
I.P.

Margate

Come home, Oedipus, all is forgiven. Mum. – Over my dead body. Dad.

*Sussex
University*

Do thou unto others – then split.

Forget Oxfam. Feed Twiggy.

I wouldn't be paranoid if people didn't pick on me.

Paraplegics, stand up for your rights.

Rainham

Penalty for improper use £25.

warning on train communication cord

– Special offer – 1p off.

If I were you I'd avoid this place like the plague.

Eyam, Derbyshire

Don't clean me. Plant something.

on a dirty car

If you can read this, you are straining at an angle of 45 degrees.

written low down on a lavatory door, Sydney

BALLS
to
PICASSO

*T*hree-channel TV sets
guaranteed working perfect,
£10. – As advertised on *Police 5.*

Oxford Circus

*N*o Pope in Northern Ireland.
– Lucky old Pope.

Belfast

*K*eep Britain tidy – kill a
tourist.

*B*e Security Conscious.
– Because 80% of people are
caused by accidents.

*W*hat has posterity ever done
for me?

*W*omen's faults are many,
Men have only two:
Everything they say
And everything they do.

Ladies,
Liverpool

61

Predestination was doomed to failure from the start.

York
University

What will you do when God comes to Liverpool? – Switch St. John to inside left.

trad.

Princess Anne is already married to Valerie Singleton.

Ladbroke Grove,
1973

Do not adjust your mind, there is a fault in reality.

Brighton

Sudden prayers make God jump.

Save trees – eat a beaver.

Leicester

This is your last chance to stay a virgin.

on railway communication cord

Before you meet your handsome prince you have to kiss a lot of toads.

*Ladies,
Chorlton-cum-Hardy*

Buy now while shops last.

Londonderry

And the angel said unto the shepherds, 'Shove off. This is cattle country.'

Royal College of Art, London

Some girls shrink from sex. Others just get bigger . . . and bigger.

Luton

Procrastinate now!

> *Lincoln College,*
> *Oxford*

Are you tired of sin and longing
for rest?
(church poster, to which the
traditional addition is:)
If not, phone Bayswater ****

An advertisement for the
London Underground showed
Henry VIII buying a ticket
and saying, 'Tower Hill return,
please.' Someone added:
And a single for the wife.

Snow White thought 7-Up was
a soft drink until she
discovered Smirnoff.

Wall, it's a wonder you don't
crash
Under the weight of all this
trash.

Pope Innocent is pious, OK

Sociology degrees, please take one.

*next to lavatory
paper dispenser,
York University*

Extramural lecture
announcement:
The Unexpected in Obstetrics.
– Mary had a little lamb.

*Oedipus
was a
nervous
rex.*

Soldiers who wish to be a hero
Are practically zero.
But those who wish to be
civilians –
Jesus, they run into millions!

GI trad.

Don't spray it, say it.

*sprayed on a wall
in London NW1*

I thought, until I discovered
Professor ******

Cambridge

I thought Smirnoff was a tank
commander until I discovered
Zhukov.

Synonyms govern, all right.

Roget's Thesaurus dominates,
regulates, rules, OK, all right,
adequately.

Hull University

I like sadism, necrophilia and
bestiality. Am I flogging a
dead horse?

Spanish punks rule, olé!

Stick up for your Dad.
He stuck up for you.

There is no good, there is no bad, there is only truth.
– Have you looked out of the window lately?

New York

*D*id you make New York dirty today? – No, New York made me dirty.

*J*esus was a foreigner too.

reminder to
opponents of
migrant workers
Switzerland

*S*tockhausen is terrible, especially when you tread in it.

Brighton

*P*ress this button for fifty-second speech from Mr Callaghan.

automatic hand-
dryer, Keele

Road safety notice outside school:
Drive carefully. Don't kill a child. – Wait for teacher.

Texans are living proof that Indians screwed buffaloes.

> *Fairbanks, Alaska*

This continual redecoration is a suppression of free speech.

> *British Museum*

Keep this bus tidy. Please throw your tickets out of the window.

Tolkien is Hobbit-forming.

> *Balliol College, Oxford*

Kick out the Tories.
– And look what happens.

> *Bristol*

GRAFFITI

*O*wing to lack of interest
tomorrow has been cancelled.

*University of
Wisconsin*

I was a professional journalist
until I discovered the *Tonight*
programme.

*BBC TV
studios,
1975.*

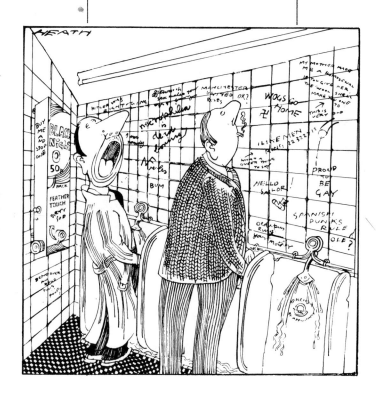

Jesus Saves.
– but Bremner scores on the rebound.

*trad., with
different
footballers'
names inserted*

Jesus Saves.
– Today he's the only one who can afford to.

Chatham

Tutankhamun has changed his mind and wants to be buried at sea.

DRINK
VARN
A LOVEL'

*V*D can be cured if treated early.
– So can kippers.

*Y*ou can do it in an MG.
– Don't boast about your
Triumphs.

*G*ravity is a myth. The earth
sucks.

Swansea

*W*hen God made man she was
only testing.

London W11

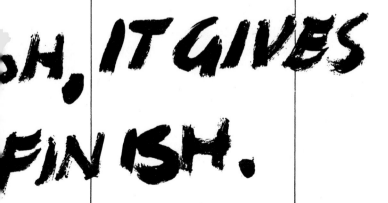

A woman without a man is like a fish without a bicycle.

> *penned as a Women's Lib. slogan, this was met by the male response:*

Yes, but who needs a stationary haddock?

Psychology is producing habits out of a rat.

Racial prejudice is a pigment of the imagination.

> *Southampton*

Place 50p in slot, wait for coin to drop, pull handle out, push back firmly

> *contraceptive vending machine instructions, which elicited the comment:*

If this is sex it sounds extremely boring.

IF USED ON THE PREMISES SUBJECT TO V.A.T.

contraceptive
vending machine

Rally, Hyde Park, Sunday.

Signed,
Queen Elizabeth.

LYSDEXIA

Boston, Mass.

Marijuana is the thinking
man's cigarette.

Chase Burnett,
British
Columbia

Cowardice rules – if that's OK with you.

London, N3

Squat now – while stocks last.

on fence round property awaiting demolition, North Kensington

Today's pigs are tomorrow's bacon.

Police station

I think Elsie reads *Reader's Digest.* – I do believe she writes it.

London WC1

THROW WELL
THROW SHELL

Belfast

Reality is an illusion produced by alcoholic deficiency.

Newcastle

Rugby is a game played by gentlemen with odd-shaped balls.

York University

I really don't like these places at all,
The seat is too high and the hole is too small.

(Underneath someone else had written:)

To which I must add the obvious retort:
Your backside's too big and your legs are too short.

trad.

Religion is man's attempt to communicate with the weather.

*Kingsbridge,
Devon*

Do as you are told – then revolt.

Hammersmith

Romans Go Home.

Maiden Castle

Buy me and stop one.

contraceptive vending machine, Tunbridge Wells. Alternatively:

Buy two and be one jump ahead.

Crewe Station

Queensberry Rules, K O

SLIDE RULES, OK

Roses are reddish
Violets are bluish.
If it wasn't for Jesus
We'd all be Jewish.

Amsterdam

Nixon is a Cox-sacker.

Washington,
1973

Since writing on lavatory walls
is done neither for personal
acclaim nor financial reward it
must be the purest form of art.
Discuss.

Kingston

Jesus Saves.
– Moses invests.
– Onan spends.

trad.

Two people in every one who
works for the BBC is
schizophrenic.

London WIA IAA

Radio 4 over-fortifies the over-forties.

Oedipus. Call your mother.

Heathrow

I used to think that nightingales sang in tune until I discovered Stravinsky.

Royal Academy of Music

Sex can stunt your growth.

Now he tells me!

*O*n an Elliott's advertisement in the Tube showing two young models wearing thigh-high woollen boots someone had written:

This insults and degrades sheep.

*R*eality is for people who can't cope with drugs.

*T*he Romans came to Shrewsbury in 53 AD and bugger all has happened since.

GI graffito, 1940s

*S*tamp out graffiti now.

Shooters Hill.

*C*ontraceptive vending machines have been known to carry the words 'Made in the UK' or 'Approved to British Standard BS 3704' or 'Absolutely safe and reliable', to all of which the traditional response has always been:

So was the Titanic.

THE KING
OF SIAM
RULES
BANGK, OK

—

ROONER SPULES

OK

Veni
Vidi
Vivi

Gents, Bexley

Virginity is oppression.
Liberation now.

*Leicester
University*

The wages of sin is death and
the wages at **************
are even worse.

trad.

We are normal and we dig
Bert Weedon.

Leeds University

Samson was a strong man,
He could break an iron hoop.
But he never could have done
the feat
If he'd lived on prison soup.

Wakefield gaol

81

*T*ry Yoga.
– It's made out of real milk.

*F*rench dockers rule au quai.

> *Wolverhampton
> station*

*T*here was no way. Zen there
was.

> *London N8*

*I*s the Regent's Park Toilet a
Zulu?

*V*idi.
Vici.
Veni.

*H*ypochondria is the one
disease I haven't got.

*W*ET PAINT.
– This is not an instruction.

*L*egalise telepathy.
– I knew you were going to
say that.

*T*here are Pharaohs at the
bottom of our garden.

Cairo hotel

I thought Wanking was a town
in China until I discovered
Smirnoff.

Vindaloo
purges the
parts
the
other curries
cannot
reach .

George
Gershwin
rules,
'Oh, Kay!"

Sod the Jubilee – yeah!

London,
NW1, 1977

Rodgers and Hammerstein
rule, Oklahoma.

London pub

I hate graffiti.
– I hate all Italian food.

Cambridge

God is dead

OH NO IM NOT

*I*t's a lie. I was never here.

(Signed) Kilroy

*R*ita loves Malcolm.
(happy ending:)
Rita married Malcolm.

Dover

*T*his wall will shortly be
available in paperback.

Penrith

PERFORATION IS A RIP OFF.

Knaresborough

Mark my words, when a society has to resort to the lavatory for its humour, the writing is on the wall.

Alan Bennett,
Forty Years On

Lo, when the wall is fallen, shall it not be said unto you, Where is the daubing wherewith ye have daubed it?

Ezekiel 13:12

*I*n the beginning was the word. And the word was 'Aardvark'.

*A*bandon hope - Pandora took the money.

Stratford-upon-Avon

*A*bsolute zero is cool.

Wimbledon

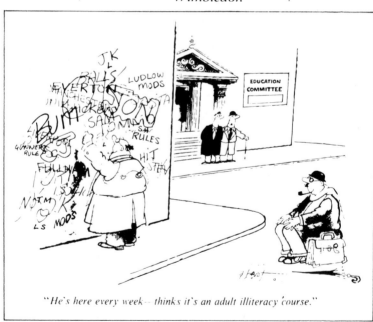

"*He's here every week—thinks it's an adult illiteracy course.*"

KINDLY ADJUST YOUR
DRESS BEFORE LEAVING
- as a refusal often offends.

ISAAC
NEWTON
WAS RIGHT
+HIS <u>IS</u>
THE CENTRE
OF GRAFFITI

GOD LOVES YOU
- so does the vicar.

*gents' lavatory,
Cricklade*

89

*C*alling all animals lovers! We wish to inform you that your habits are illegal.

*O*K, so I'm cured of schizophrenia, but where am I now when I need me?

> *Manchester University*

*D*oris Archer is a prude.

> *Crouch End*

*N*ot enough is being done for the apathetic.

> *Clifton, Bristol*

I couldn't care less about apathy.

*W*e buy junk and sell antiques.

> *written in dust on*
> *old van*

*A*NARCHY NOW
- pay later.

> *Oxford Circus*
> *Underground*
> *Station*

*P*ut the anal back into analysis.

> *Manchester*

I'D GIVE MY RIGHT ARM
TO BE AMBIDEXTROUS
- you can have mine, I'm
left-handed

*D*AVE ALLEN FOR POPE

> *Wolverhampton,*
> *after death of*
> *Pope Paul, 1978*

*D*AVE ALLEN FOR POPE
THIS TIME

> *after death of*
> *Pope John Paul I*

~~ALGÉRIE FRANCAISE~~
~~ALGÉRIE ALGÉRIENNE~~
~~ALGÉRIE FRANCAISE~~
~~ALGÉRIE ALGÉRIENNE~~
~~ALGÉRIE FRANCAISE~~
ALGÉRIE ALGÉRIENNE

*W*hy can't you bloody frogs
make up your bloody minds!

Paris, early 1960s

DID YOU KNOW
SPIRO AGNEW IS AN
ANAGRAM OF
'GROW A PENIS'?

*Edinburgh
University*

ACCOUNTING FOR
WOMEN
- there's no accounting for
women.

*poster in London
Underground*

*W*HAT MADE ELIZABETH
ARDEN?
- when Max Factor.

Folkestone

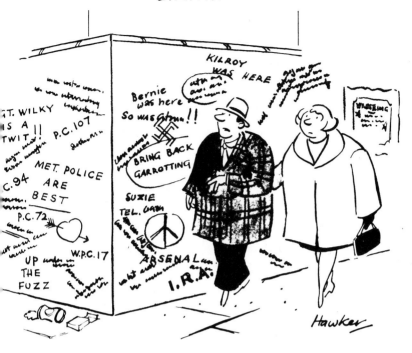

"What are the police doing about it, that's what I'd like to know?"

Please do not ask for bail, as a refusal often offends.

> *in the dock,*
> *Willesden*
> *Magistrates Court*

8 OUT OF EVERY 10 MEN WRITE WITH A BALL-POINT PEN
- what do the other two do with it?

*T*HE ARMY BUILDS MEN
- build me one, Veronica.

recruiting poster

*M*y Uncle Fred died of
asbestosis - it took six months to
cremate the poor devil.

Southsea

SLIDE RULES

*O*bservation astronomique
- trois heures de Vénus, trois ans
de Mercure.

Geneva

*S*ycophancy rules - if it's OK by
you.

Hambleden

*A*VENUE ROAD
- what's wrong with the old one
then?

*W*ant a quick time, long time, companionship, black leather bondage? Ring Maggie and Maureen, Edinburgh ★ ★ ★ ★ (Mourning only) (*sic*)

phone booth,
Princes Street

*P*am Ayres is Eddie Waring in drag.

$$_{?.}x^2 \sqrt{K. \text{SIN } 0.01 x}$$

*S*TOP THE BAATH
TERROR IN IRAQ
- have a shower.

Oxford Circus
Underground
station

*I*F YOU SEE AN
UNATTENDED BAG
- go up and talk to her.

ditto

*I*s a lady barrister without her briefs a solicitor?

*University College,
London*

EAT MORE BEANS - AMERICA NEEDS GAS

US

*B*eethoven was so deaf, he thought he was a painter.

*Inter-City train,
Newcastle-
Sheffield*

*W*hen Bernadette takes hers down, we'll take ours down.

*Loyalist slogan,
York Road,
Belfast, about
removal of
barricades*

The best things in life are duty free.

Heathrow airport

I bet you I could stop gambling.

Sydney

Men call us birds. Is that because we pick up worms?

Oxford

Christmas comes but once a year Thank God I'm not Christmas.

Luton

Bisexual man, aged 30, seeks young married couple.

Dresden

*B*ut you'd look sweet upon the seat of a bisexual made for two.

*S*cots rule, och aye!

Carlisle

*B*lackheads go down well in Hackney.

*Goldsmiths
College, London*

*S*omeday my boat will come in -and with my luck I'll be at the airport.

*B*lessed Mary, we believe
That without sin thou didst
 conceive.
Holy Virgin, thus believing,
May we sin without conceiving?

*Edinburgh
University*

*B*urgess loves Maclean.

*reputedly written
on a wall in
Moscow by the
actor Ernest
Thesiger while on
an Old Vic tour,
1950s*

*K*INDLY PASS ALONG THE
BUS
AND SO MAKE ROOM FOR
ALL OF US

*London Transport
poster*

- That's all right without a doubt
But how the hell do we get out?

*L*ET BUSES PULL OUT

sign on bus

- and help reduce the minibus
population.

*M*AKE SOMEONE HAPPY.
- strangle Buzby.

*T*hat'll teach you to make lumpy custard.

*speech balloon
added to poster
for film* The Blue
Max *which
showed German
pilot shooting
down fighter plane*

*K*EEP THE BOAT PEOPLE OUT
- sink the Irish ferry.

Bristol, 1979

*W*hat Katy Did
What Katy Did With A Shetland
 Pony
Katy And Her Foal

*B*iggles Flies Open
Biggles Does a Jigsaw Puzzle
Biggles Falls Over
Biggles Translates Nietszche

I f the human brain was simple
enough for us to understand
we'd be so simple we couldn't.

E at bran and the world will
fall out of your bottom.

Sheffield

DID IT FOR
INSURANCE

F ucque Braque

Aldeburgh

I wish these walls were made
of bread
I'd eat my way to Holyhead.

*in cell, Swansea
Magistrates Court*

Bread is the staff of life
Toast a decadent capitalist
 luxury.

on bakery wall

I can't breathe.

London

A Britannia is better than a
Trident, because four screws
always beat three blow-jobs.

Gatwick airport

I'll BE
BUGGERED IF
I JOIN THE

BRITISH RAIL ADVISE
THAT THIS RIGHT OF WAY
IS NOT DEDICATED TO THE
PUBLIC
- neither is British Rail.

COME THE REVOLUTION,
BRITISH RAIL WILL BE THE
FIRST TO GO
- if they arrive on time.

Fleet, Hampshire

George Brown for God.

*Ringwood,
Hampshire*

Bruggle strothers.

Cardiff University

IBERALS

Hampstead, 1979

STREAKERS
YOUR END IS

THINK!

Wayside Pulpit

- or thwim.

THINK!

ditto

- thoap.

Free the Indianapolis 500.

Man needs God like a goldfish needs a motorbike.

Faculty of Theology, King's College, London

BEWARE N SIGHT

Los Angeles

Jesus shaves.

> *on Gillette ad*

Free the Chiltern Hundreds.

Sex is all right but it's not as good as the real thing.

> *Hexham*

It takes 51 Irishmen to write on a wall. One to hold the pen and the other 50 to move the wall.

> *Bristol University*

WALLS HAVE EARS
- I've just discovered one in my
ice cream.

Lapworth,
Warwickshire

CASTRATE RAPISTS
- *have a ball.*

London
Underground

Schizophrenia
RULES,
OK, OK.

I GOT MY JOB THROUGH
THE NEW YORK TIMES
- so did Castro.

Cats like plain crisps.

Deptford

108

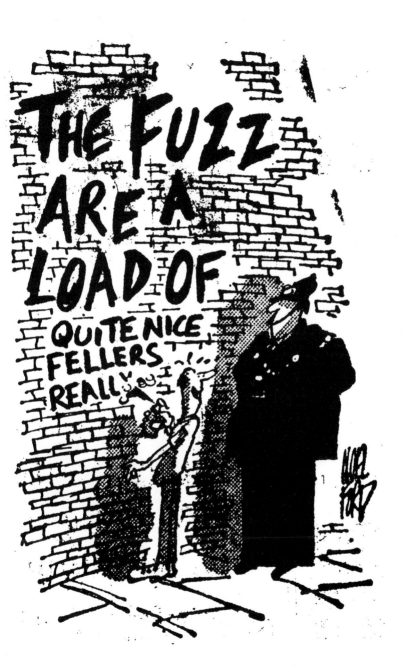

CAUTION AIR BRAKES

> *on lorry seen in*
> *Oxford, changed*
> *to:*

- caution tea brakes.

Man is born free but
everywhere is in chains.
Smash the cistern.

> *Bristol University*

Don't study medicine and law
at the same time, it tries your
patients.

> *Birmingham*
> *Medical School*

Where's the bloody chalk then?

> *carved on*
> *blackboard*
> *supplied for*
> *graffiti in Barnet*
> *pub*

CHELSEA ARE MAGIC

— WATCH THEM DISAPPEAR FROM THE FIRST DIVISION

*C*yril Chaos is 25.

Bath

*C*hastity is its own punishment.

High Holborn,
London

*J*esus Christ is alive and well and signing copies of the Bible at Foyle's.

*W*hy go to Burton's? Let the local CID stitch you up.

*I*t is now beyond any doubt that cigarettes are the biggest cause of statistics.

I thought cirrhosis was a type of cloud, until I discovered Smirnoff.

The Louvre, Paris

Sceptics may or may not rule, OK.

THE WORLD IS FLAT.
CLASS OF 1491.
- all the girls in our world are flat. Class of 1973.

Princeton

CLEANLINESS IS NEXT TO GODLINESS
- only in an Irish dictionary.

You are never alone with a clone

Aldershot

Proposed site for coat hook.

indicated by small circle on back of lavatory door, Ashford

*D*escartes thought he was here.

*C*oito ergo sum.

*Army and Navy
Stores, London*

*S*ale this week - three pulls,
half a crown.

*on train
communication
cord*

I USED TO BE
CONCEITED
BUT NOW I'M
ABSOLUTELY
PERFECT

Dartford

ASSIST THE CONDUCTOR, GIVE THE RIGHT CHANGE

notice in Bournemouth bus, changed to:

- Amaze the conductor, give the right change.

If you're not confused, you're misinformed.

Bartlett School of Architecture, London University

Constipation is the thief of time. Diarrhoea waits for no man.

Let them eat Corgi.

Hammersmith, during Jubilee Year bread strike

115

*L*iving in Coventry is about as interesting as watching a plank warp

Coventry

DO NOT THROW TOOTHPICICS IN HERE. THE CRABS CAN POLE VAULT.

*T*he Rubaiyat rules, OK.

*University
Library,
Cambridge*

*J*ESUS CHRIST IS COMING

*on railway bridge
over obscure
branch line in
Yorkshire*

- only if he remembers to change at Darlington.

Save fuel. Get cremated with a friend.

Liverpool

THE CREMATION OF MR _____ WILL TAKE PLACE AT GOLDERS GREEN CREMATORIUM AT 2.30
- please put him on a low gas. Can't get there till 4.

Covent Garden, London

Nationalise crime and make sure it doesn't pay.

Henley

Crime doesn't pay, but the hours are good.

Staines police station

GOD IS BLACK
- yes, she is.

Cunnilingus is a real tongue-twister.

Maryport,
Cumbria

If Typhoo put the T in BRITAIN who put the CUNT in SCUNTHORPE?

comprehensive
school, Sussex

dandruff
is
tasteless

London

Don't laugh. It might be your daughter in here.

in dust on passion
wagon

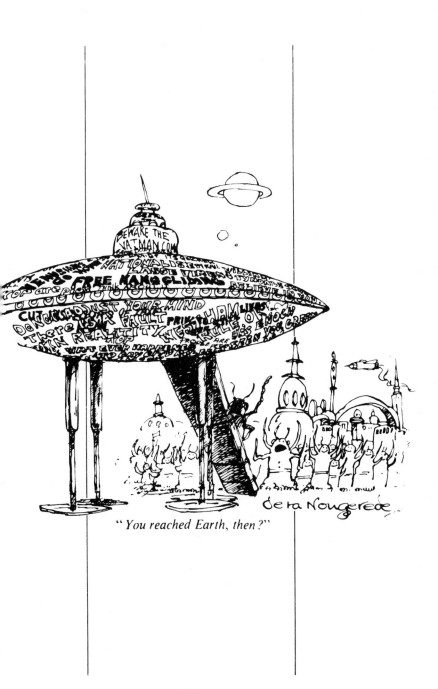

"*You reached Earth, then?*"

*W*HAT ARE YOUR
CHANCES OF GETTING
PREGNANT TONIGHT?

> *family planning*
> *poster*

- chance would be a fine thing.

*G*eorge Davis is ~~innos~~ ~~innoss~~ guilty

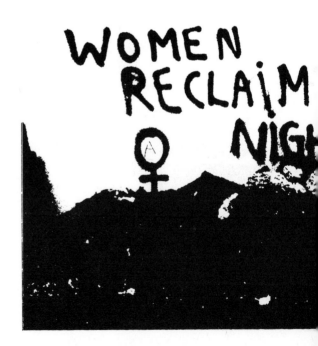

*D*ead people are cool.

*D*eath is hereditary.

Coventry

*K*EEP DEATH OFF THE
ROADS
- drive on the pavement.

Palmers Green

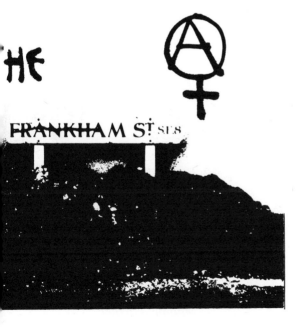

*T*O MY FATHER AND
MOTHER

> *dedication in*
> *learned textbook*
> *on jurisprudence*

- thanks, son, it's just what we
wanted.

*R*emember the truth dentist.

*S*UPPORT WOMEN'S LIB
- use his razor.

*R*oyce Rolls, KO

*D*ON'T BUY THIS CHEWING
GUM, IT TASTES OF
RUBBER
- yes, but it lasts all day.

> *on contraceptive*
> *vending machine*

COUNT DRACULA YOUR BLOODY MARY IS READY

GRAFFITI

*T*his woman degrades adverts.

*D*isembowelling takes some guts

Coventry

*B*eware of the doc.

outside vet's,
Sidmouth

*P*LEASE ADJUST
YOUR DRESS
BEFORE LEAVING
- I don't wear one.

gents' lavatory,
Old Trafford

*G*LORY TO GOD IN THE
HIGH ST

church poster,
altered

*E*LVIS LIVES
- and they've buried the poor bugger!

Holborn Underground station

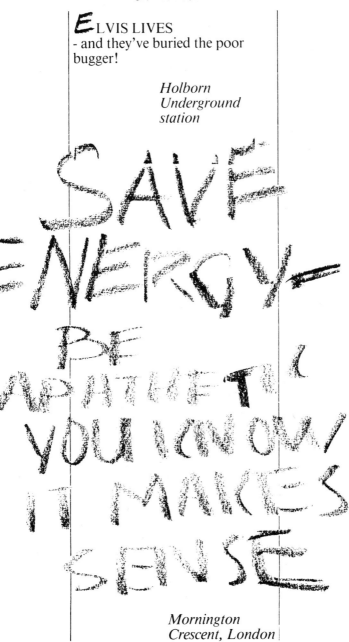

SAVE ENERGY— BE APATHETIC YOU KNOW IT MAKES SENSE

Mornington Crescent, London

DO YOU HAVE A DRINK PROBLEM?
- yes, I can't afford it.

Fit Dunlops and be satisfied.

> *addition to*
> *contraceptive ad,*
> *Hereford*

Easter is cancelled this year. They've found the body.

> *Chicago*

So has Christmas.They've found the father.

> *Newcastle*
> *University*

Why don't you give Elgin his marbles back?

> *British Museum*

Yesterday I couldn't spell engineer. Now I are one.

*Loughborough
University*

EUNUCHS UNITE – YOU HAVE NOTHING TO LOSE

Avoid the end of the year rush -fail your exams now.

*London teaching
hospital*

Examinations-Nature's laxative

*City of London
Polytechnic*

Procrastination will rule one day, OK?

Graffiti should be obscene and not heard.

Like a nice time, dearie? Phone 123.

phone booth

WHAT YOU SHOULD DO IF THE THAMES FLOODS
- breast-stroke.

*Moorgate
Underground
station*

POTASSIUM
EXTHOXIDE
RULES

C_2H_5OK.

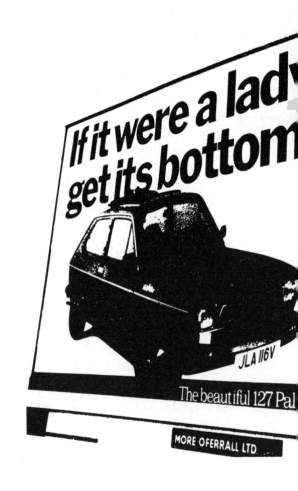

130

131

*I*s this the face that shipped a thousand lunches?

> *over mirror in*
> *hotel much used*
> *by business*
> *clientele,*
> *Gloucester*

*F*art for peace.

> *Hammersmith*

A fate worse than death is better than dying.

> *Dublin*

I used to think Fellatio was a character in Hamlet until I discovered Smirnoff.

*G*uy Fawkes was the sanest man who ever went into the Houses of Parliament - and look what happened to him.

I never used to be able to finish anything, but now I

Stinky Finkelstine cannot adjust to his environment.

New York City

Old fishermen never die - they just smell that way.

*T*here was a young man in Florence
To whom all art was abhorrence
So he got slightly tipsy,
Went to the Uffizi,
And peed on the paintings in torrents.

*The Uffizi,
Florence*

SAY IT WITH
FLOWERS - GIVE HER
A TRIFFID

Oxford

"This is going to make a bloody fantastic four-page, full-colour spread . . ."

". . . graffiti, the new art-form of the underprivileged masses . . ."

"... the voice of the proletariat screaming
its protest from the walls of the
decadent capitalists' city strong-hold..."

"Look at that, all over our car,
the dirty little bastards!"

Wallace Ford (1897-1966) was a British-born film actor who went to Hollywood in the early 1930s and after playing a number of near-leading roles was cast mostly as a supporting character actor. On his grave was the epitaph, 'At last I get top billing'. But someone wrote above his name: Clark Gable and Myrna Loy, supported by . . .

*F*REE ASTRID PROLL
- no, thank you, I've got two already.

*W*hat kind of fuel am I.

written in dust on oil tanker lorry

PERSONAL
PROBLEMS
RULE, B.O

Hornchurch

All men eat but Fu Manchu.

Israel

GBH really scrolls your nurd.

Norwich

Donald Coggan cheats at Scrabble

Canterbury

P-P-Patrick Campbell
Ru..Ru..Ru..Rules

Yorick is a numb skull.

Stratford-upon-Avon

De Gaulle est pire qu'Hitler.
Mais plus con.

Orly

I have nothing to declare but my genes.

*G*eography is everywhere.

> *Bedworth,*
> *Warwickshire*

*E*lvis rocks in his box.

> *Hungerford*
> *Bridge, London*

*I*t's time they gave George VII a go.

GERMAN
SHEPHERDS
CAN BE FUN
MRS ROBINSON

*P*edants rule, OK - or, more accurately, exhibit certain of the trappings of traditional leadership.

Watford

*G*od made animals, great and
 small,
Some that slither and some that
 crawl -
And Rochester police employ
 them all.

Strood

*I*f you feel strongly about graffiti, sign a partition.

Bray

*B*RING BACK THE GOONS - I was unaware the Goons had gone.

Perth, Scotland

*I*f the enemy is not giving up, destroy him. GORKI.

Soviet Union,
WWII

*I*f the friend is not giving up, destroy him.

Moscow, after
invasion of
Czechoslovakia,
1968

*G*rass is Mother Nature's way of saying 'High!'

Radcliffe Station,
Manchester

*P*eter Hain for Queen.

St Pancras
Station, London

*H*alitosis is better than no breath at all.

ILLITERATES

WATCH

THIS

SPACE

*T*he trouble with God is he thinks he's Peter Hall.

*National Theatre,
London*

HANG

BLAST

AND SOO

The hamburgers in this
establishment have been
endorsed on TV by Sir Robert
Mark.

GLIDING

BASEBALL

CYCLING

Sheffield

No hand signals - the driver of this vehicle is a convicted Arab shoplifter.

The hangman let us down.

Luton

NOSTALGIA HOKEY-

HAPPINESS IS A WARM EARPIECE
- yes, but ecstasy is a warm codpiece.

telephone ad,
Ravenscourt Park

The hatchback of Notre Dame.

in dust on Renault
car seen in
Strathclyde

50 years and this is all I get.

speech balloon coming out of Warren Beatty's mouth on poster for Heaven Can Wait *in which he is shown as an angel looking at a gold watch, Chalk Farm Underground station, London*

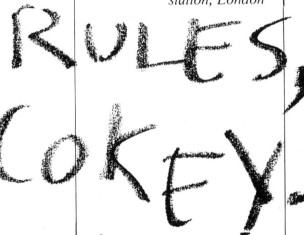

RULES, COKEY.

*H*ook Norton Ale reaches the parts Heineken daren't mention.

Hereford

*H*eteros go homo.

Paris

WHAT DO YOU HAVE IN COMMON WITH YOUR HUSBAND?

ad for series in women's magazines

- we were both married on the same day.

A fertile imagination is no compensation for vasectomy.

Melbourne

My wife wears black rubber gear and whips me, Ohhhh Kay!

Bristol

Let's keep incest in the family.

Sausalito

Indian driver - smoke signals only.

lorry on M1

DUE TO INDUSTRIAL
ACTION THIS TOILET WILL
BE CLOSED ALL DAY ON
MONDAY
- please do all you can today.

My inferiority complexes aren't
as good as yours.

Wellington

Beat inflation - steal.

Hastings

EVERY WEEKDAY 25 INTER-
CITY TRAINS LEAVE
SOUTHAMPTON

British Rail poster

Only Seven
Get Back

*I*MPORTANT NOTICE. WILL
ALL TRAVELLERS VISITING
IRAN PLEASE VISIT THE
BRITISH EMBASSY
IMMEDIATELY ON
ARRIVAL

poster at
Heathrow aiport

- and then go next door to the
psychiatrist.

I like it and him in that order.

ladies lavatory,
Blackpool

*J*ack is nimble
Jack is quick
But Jill prefers
The candlestick.

traditional

*J*AWS 3
- just when you thought it was
safe to go to the toilet.

HOW LABOUR WILL COPE

poster

- next week, how to nail jelly to the ceiling.

I wanted to be a judge but they found out my Mum and Dad was married.

cell under court

Mañuel rules, Oh-¿Qué?

Fawlty Towers

LORD DENNING RULES, OK
- House of Lord overrules, OK.

*E*mmanuel Kant but Genghis Khan.

British Museum

*T*his is an Oxford college. Think of it more as a Fair Isle sweater.

Keble College,
Oxford

*H*ere lies the grave of Keelin
And on it his wife is kneelin;
If he were alive she would be
 lying,
And he would be kneeling.

Dublin,
traditional

$$B4\, i\sqrt{u}\, \frac{RU}{16}\,?$$

*A*yatollah Khomeini is a Shiite.

*P*LEASE DO NOT DEFACE
THESE WALLS
- Killjoy is here.

I've run out of tapes.
 Krapp.

Exeter

*T*his door is now in its second edition.

on newly-decorated, previously graffiti-strewn door, Monash University, Melbourne

*T*he views expressed on this wall are not necessarily those of the Aberystwyth Urban District Council.

80% OF BISHOPS TAKE *THE TIMES*

the other 20% buy it.

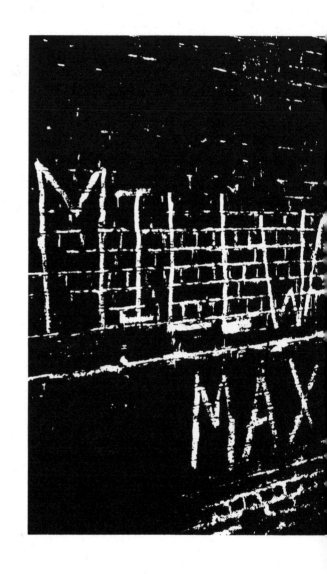

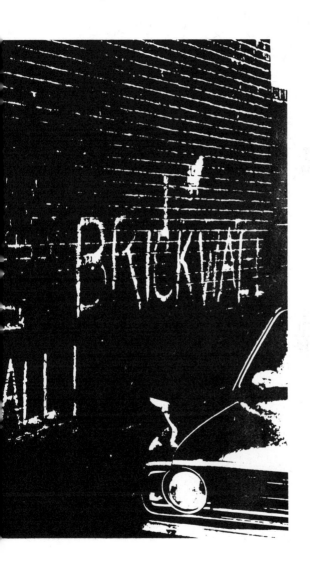

153

*W*omen in labour keep capital in power.

Oxford

*L*ABOUR IS THE ANSWER
- if Labour is the answer, it's a bloody silly question.

*H*e may have hairs on his chest
-but, sister, so has Lassie.

ladies' lavatory, Bristol

*H*ere did I lay my Celia down. I got the pox and she got half a crown.

scratched on window, Chancery Lane, London, 1719

*D*efinition of a lecture: a means of transferring information from the notes of the lecturer to the notes of the student without passing through the minds of either.

Warwick University

CONSIDERATION RULES, IF THIS OK

You will never walk alone with schizophrenia.

In a survey carried out to see what men liked about women's legs, 27% said they preferred women with fat legs and 15% said they preferred women with thin legs. The remaining 58% said they preferred something in between.

Reading

Vote Liberal - or we'll shoot your dog.

London, 1978

Liberals are a Labour-saving device.

London School of Economics, 1978

*V*ote Liberal - and feel a man.

Cambridge

*D*on't worry, Liddle Towers
-they'll probably name a block of
flats after you.

*Manchester
University*

$$\text{Life} = \text{Death} \atop \displaystyle\int_{\text{Birth}^*} L(\text{Happiness}).dt$$

*R*ichard the Lion-Heart is alive
and well and asking Christian
Barnard for his money back.

*L*ife is a sexually transmitted
disease.

Lancaster

*Life is an integral function of
happiness over the time between
birth and death.

*T*HE FIRST THREE MINUTES
OF LIFE CAN BE THE MOST
DANGEROUS

hospital notice

- the last three minutes are pretty
dodgy, too.

*D*O NOT USE LIFT IN CASE
OF FIRE
- just jump.

Cardiff

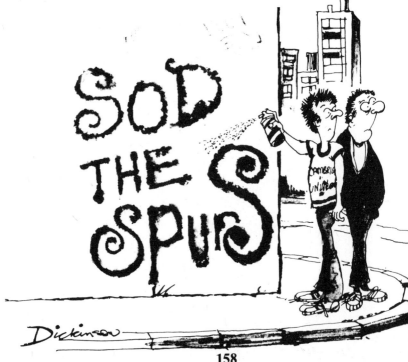

*W*ould the last person to leave the country please switch off the lights.

*J*argon rules, ongoing agreement situation.

*I*F THIS MACHINE IS OUT OF ORDER SEE THE LANDLORD

> *on contraceptive
> vending machine*

- and if it's in order, see the barmaid.

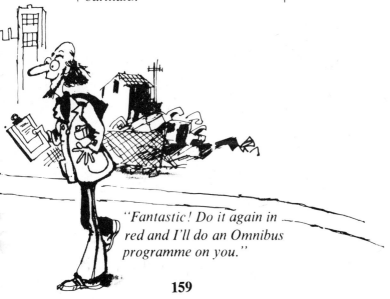

"Fantastic! Do it again in red and I'll do an Omnibus programme on you."

I choked Linda Lovelace.

*W*ARNING. PASSENGERS ARE REQUESTED NOT TO CROSS THE LINES
- it takes hours to untangle them afterwards.

Warrington

*B*eware the Irish limbo dancer.

written by gap at top of lavatory door

I'd rather have a full bottle in front of me than a full frontal lobotomy.

Leicester University

*L*ogic is on heat.

Belfast

*L*ondon Pride don't want cheap publicity.

*painted on
hoarding, Ealing*

*K*eep London tidy - eat a pigeon a day.

*Roman
amphitheatre,
Trier*

*B*ob Harris is a loudmouth.

Worthing

Until I discovered women, I thought love was a pain up the arse.

Hatfield Polytechnic

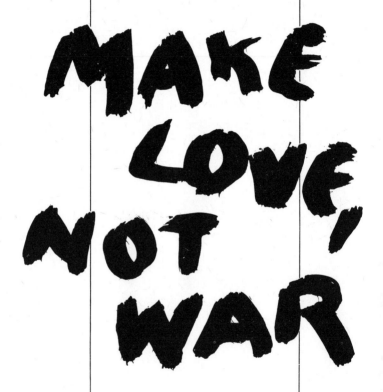

MAKE LOVE, NOT WAR

I'm married, I do both.

*L*ORD LUCAN WAS HERE
- no I wasn't.

*B*ad spellers of the world, untie!

> *Southgate*
> *Underground*
> *station*

*N*orman Mailer is the master of the single entendre.

*M*ake magic not tea.

> *Strood*

*T*hank God, a man at last.

> *on lifting seat in*
> *lavatory, Girton*
> *College,*
> *Cambridge*

What a lot of cunning linguists you all are.

at foot of graffiti-strewn wall

Marriage is a wonderful institution - but who wants to live in an institution?

MASTURBATION STUNTS THE GROWTH

eight feet from the floor:

- Liar!

One thing about masturbation -you don't have to look your best.

Another thing about masturbation - you meet a better class of person.

*I*f God had not meant us to write on walls, he would never have given us the example.

Exeter

*C*an we have a new wall.

at foot of graffiti-
strewn wall,
Holborn

*M*AX HEADROOM
- is cool.

Orpington

*F*ree the ITV Seven.

*O*nly the mediocre are always at their best.

Hyde Park,
London

MERSEY DOCKS AND
HARBOUR BOARD
- and little lambs eat ivy*.

Hurlingham rules, croquet.

Mickey Mouse is a rat.

Bishop's Castle

How do girls get minks? - the
same way minks get minks.

Moking is not a wealth hazard.

*in dust on Mini-
Moke*

*A popular Second World War
song went: 'Mares eat oats and
does eat oats / And little lambs
eat ivy.'

Monogamy leaves a lot to be desired.

Monkey is the route to all people.

University of East Anglia

DESIGNED BY COMPUTER
SILENCED BY LASER
BUILT BY ROBOT

Fiat Strada ad

- driven by moron.

Mary Poppins is a junkie.

FREE COLLECTIVE
BARGAINING
- he's innocent.

Oxford

Flower Power Rules, bouque

***I**S MUFFIN THE MULE A SEXUAL OFFENCE?*
- no, but you might get Moby Dick.

Sussex University

***N**apoleon Out.*

*on Martello tower,
near Dublin*

***I**'ve half a mind to join the National Front. That's all I'll need.*

Highbury

***G**OD IS NOT DEAD*
- merely out to lunch.

*Gonville and Caius College,
Cambridge, has three gates
inscribed 'Honoris', 'Virtutis'
and 'Humilitatis'. A more recent
inscription over the archway
leading to the Gents reads:*

Necessitatis.

GRAFFITI

*H*orse power rules, neigh neigh.

*Beverley race
course*

*N*ervous breakdowns are
hereditary - we get them from
our children.

*N*eurotics build castles in the air.
Psychotics live in them.
Psychiatrists charge the rent.

*Birmingham
University*

*T*his vehicle is powered by Olivia
Newton-John's knicker elastic.

*on lorry seen in
East London*

*D*ick Nixon before he dicks you.

Bergen

*V*ote Nixon - why change Dicks in the middle of a screw?

Israel

*N*krumah for Queen.

Cambridge

*N*orman Hunter bites your leg. Norman Scott bites your pillow.

*W*hat ever did we do before we discovered nostalgia?

*N*OTHING ACTS FASTER THAN ANADIN - then take nothing instead.

Covent Garden

*N*ye weeps for Labour.

Caerphilly

Repent ye, for the kingdom of Bevan is Nye.

Northampton
1959 General
Election

Definition of a nymphomaniac: a girl who trips you up and is under you before you hit the floor.

Warwick
University

DORIS IS A NYMPHO MANIAC

— sadly not true

Leighton Buzzard

French diplomats rule, au Quai.

Keble College,
Oxford

OEDIPUS
NERVOUS

ORAL SEX IS

WAS A

REX

A MATTER OF TASTE

Ilkley

*G*od will give your whole body an orgasm when you die if you spend your life in divine foreplay.

*W*here is Lee Harvey Oswald now that his country needs him?

> *during Watergate*

*D*OESN'T ANYONE OR ANYTHING WORK ROUND HERE?

> *on 'Out of Order'*
> *sign on Post*
> *Office stamp*
> *machine*

- yes, I do. I put up the 'Out of Order' signs.

*M*AKE CHILDREN HAPPY
- support paedophilia.

> *London WC1*

*P*anic now and avoid the end of term rush.

Essex University

*J*ust because you're paranoid, it doesn't mean they're not out to get you.

Kardomah cafe ladies' lavatory, Nottingham

*W*e are the people our parents warned us about.

Harrogate

*P*atrons are requested to remain seated throughout the performance.

gents' lavatory, Leominster

*D*on't waste water - pee on a friend.

Looe (really)

An erection is like the Theory of Relativity - the more you think about it, the harder it gets.

Victoria Station, London

PENIS ANGELICUS
- Anus Mirabilis.

A PHONE CALL. IT COSTS LESS THAN YOU THINK
- soon it'll cost more than you'll believe.

It'll never get well if you picket

hospital, Ilfracombe

Pigeons eat crisps.

London NW1

IS A CASTRATED PIG DISGRUNTLED

Manchester

I'm pink therefore I'm spam.

Arrange the following words into a well-known phrase or saying: OFF PISS.

I thought Plato was a Greek washing-up liquid.

Bodleian Library, Oxford

Please don't touch me
Please don't touch
Please don't
Please do
Please
Ohhhh!

Chalk Farm
Underground
station, London

Satisfaction guaranteed - or
double your refuse refunded.

on dustcart,
Cwmbran, Gwent

The philosopher Amnaeus
Seneca is the only Roman writer
to condemn the bloody games.

Pompeii, AD 79

What lasts longer? A Pope or a
wine-gum?

Glasgow, 1978

Keep the Pope off the moon.

Belfast

Not so much a pleasure
More a sense of joy:
I got to the liver
Before Portnoy.

*Leicester School
of Education*

PRAYER MEETING AT 7.30
ON WEDNESDAYS.
REFRESHMENTS PROVIDED
AFTERWARDS
- come to pray, stay to scoff.

Birkenhead

Being employed by this firm is
like making love to a hedgehog
-one prick working against
thousands.

Birmingham

Procreation is the thief of time.

GOD GAY?

NUDITY IS O.K. IF YOU'RE DRESSED FOR IT

IF YOU FIND PEACE CALL 6-8 0885

you have wet dreams your umbrella with you

ESMEN

A HAPPY
NEW YEAR
TO ALL OUR
READERS

Don't let
Scotland Get The Boot

GET KNOTTED GRANNY!

IF YOU HAVE BAD TEETH BLAME YOUR DENTIST

Marcel Proust is a yenta.

New York City

Start a new movement - eat a prune.

How much longer must our lives be dominated by Prussian horse-cripplers, a puerile debating society, and nebbishes from cobweb corner? Let us found a new nation under God.

How do you tell the sex of a chromosome? By taking down its genes.

Oxford

The only safe fast-breeder is a rabbit. Say 'No' to nuclear power.

Sussex University

READING MAKETH A FULL
MAN; CONFERENCE A
READY MAN; AND
WRITING AN EXACT MAN
- BACON
- a fat man

> *added to library
> inscription,
> Liverpool*

A *lavatory wall at a university
had recently been whitewashed.
Within days, someone had
divided up the wall into three
columns for future graffiti,
marked 'Sport', 'Politics' and
'Sexual Deviations'. After
another day, somebody else had
written under each heading:*

SPORT	POLITICS	SEXUAL DEVIATIONS
Up the Reds	Up the Reds	Up the Reds

Jack the Ripper lives - he
works in our laundry.

REINCARNATION IS
MAKING A COMEBACK
- over my dead body.

Billingsgate

KINDLY

FROM

ON MY

THANK

YOU.

REFRAIN
WRITING
ROCKS.
SIGNED,
GOD

in six feet high letters on granite rocks by remote desert road in Western Australia

185

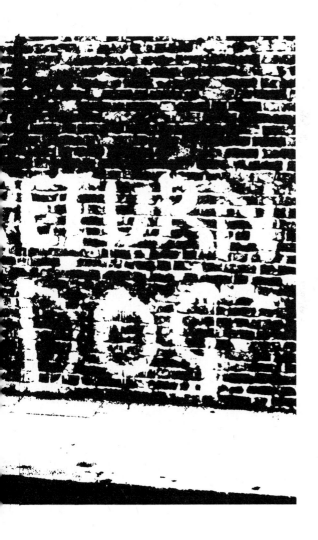

*I*f you have looked as far as this, you must be looking for something. Why not try the Roman Catholic church?

> *graffito written*
> *high up on*
> *lavatory wall,*
> *Oxford*

*I*N 1066, NEAR THIS CHURCH, THE NORMANS LANDED AND WERE REPELLED BY THE MEN OF ROMNEY
- so am I.

> *on notice,*
> *Romney parish*
> *church*

*R*oses are red
Violets are blue;
Why can't black
Be beautiful, too?

*R*oses are red
Violet's are blue
And mine are white.

*S*ado-masochism means not having to say you are sorry.

*S*alvation Army kick to kill.

New Malden

*O*h, Lord above, send down a dove
With wings as sharp as razors
To cut the throats of those who try
To lower textile wages.

Huddersfield mill, 1930s

*W*HY NO GRAFFITI?
- we're working to rule, OK

*T*his is an art form. Stop council vandals ruining it.

*D*avid Frost drools, OK

I thought a sell-out was the end of a special offer until I discovered the National Union of Railwaymen.

in guard's carriage, London Underground train

*D*o not accuse me of being anti-semantic. Some of my best friends are words.

Hammersmith

*S*EX IS BAD FOR ONE - but it's very good for two.

LIKE CAVIARE TREAT. DON'T AROUND

You're never alone if you're a
sex-maniac

Hatfield

MORT AU SHAH
- et aux souris.

Paris, 1979

DOWN WITH THE FASCIST
SHAH OF IRAN
- 's trousers.

Hull

SEX IS A
SPREAD. IT
LIKE MARMALADE.

*Middlesex
Polytechnic*

*H*immler seeks similar.
Indian gentleman seeks Simla.
Gay Nepali seeks Himalaya.

*Harrogate Royal
Baths*

DON'T SPIT
YOU
MIGHT NEED
IT

*in middle of
Simpson Desert,
Australia*

*T*he only difference between
Frank Sinatra and Walt Disney is
that Frank sings and Walt disne.

Leeds

*I*t begins when you sink into his
arms; and ends with your arms in
his sink.

Cambridge

192

GRAFFITI

*I*f you can't stop - smile as you go under.

on back of large
articulated lorry

*S*mile, they said, life could be worse. So I did and it was.

Thatchers Arms,
Norton Heath,
Essex

I used to play football for Scotland until I discovered Smirnoff.

*N*O SMOKING IN BED - and no sleeping in ashtrays.

USAF base

*I*t's quicker by snail.

on British Rail
poster

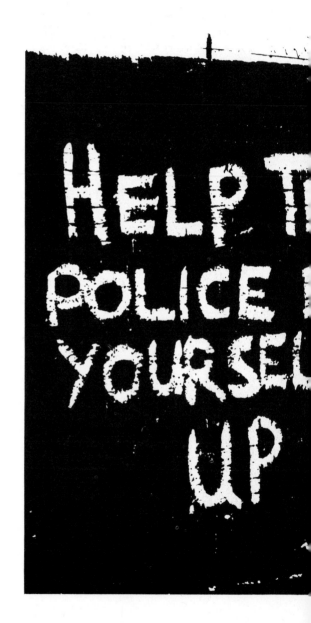

*T*his has as much to do with socialism as Cyril Smith has to do with hang-gliding.

> *on poster*
> *proclaiming*
> *Labour Party*
> *policy,*
> *London N8*

*S*ocialism is the opiate of the proletariat.

> *King's College,*
> *London*

*Y*ou've got to sock a picket or two.

*F*OUND: ONE PAIR OF GLASSES
- please write larger, I've lost my glasses.

> *BBC Engineering*
> *Training College*

*S*HAKESPEARE WAS A TRANSVESTITE
- I should know, sailor! Signed, Anne Hathaway (Mr).

> *Stratford-upon-*
> *Avon*

GRAFFITI

*K*enny fucks spiders.

Western Australia

*S*PITTING PROHIBITED
- use the Manchester Ship Canal

bus notice,
Manchester

*T*HE REV. CHARLES
SPURGEON DEPARTED FOR
HEAVEN AT 6.30 AM TODAY
- 10.45 am. Not yet arrived.
Getting anxious, Peter.

notice,
Metropolitan
Tabernacle,
London, 1892

*W*hat do you think of Stainer's
Cruxifixion? - A very good idea.

Royal College of
Music

*T*HERE'S A SHORTAGE OF
GIRLS IN OXFORD
- I don't care how short they are,
there just aren't enough of them.

*I*gnore this sign.

Los Angeles

Stamp out quicksand.

Don't flatter yourself - stand nearer.

> *gents' lavatory,*
> *Sydney*

Sterility is hereditary.

> *Swansea*

When straining, please refrain from gnawing the woodwork.

> *gents' lavatory,*
> *Prestatyn*

Streak - or for ever hold your piece.

> *Brighton*

JAMES BOND RULES OOK

SOFT SHOULDERS - warm thighs.

> *road sign,*
> *Ormskirk*

*B*runel rules, IK.

*on Western
Region Class 50
locomotive*

Sue Loves
Bob!

*gents' lavatory,
Exeter*

- either Bob is big-headed or Sue
is in the wrong place.

*O*ne man's Sunday dinner is one
woman's Sunday gone.

*Victoria Station,
London*

*S*uicide is the most sincere form
of self-criticism.

Cardiff

199

*I*t is forbidden to throw
tantrums on the line.

> *Pimlico*
> *Underground*
> *Station, London*

*H*elp Tasmanian afforestation -
plant an acorn upside down.

> *Cambridge,*
> *England*

*T*ea is more artistic than coffee

> *Mill Hill*

*T*hose who can, do - those who
can't, teach - and those who
can't teach lecture on the
sociology of education degrees.

> *Middlesex*
> *Polytechnic*

*O*ther vice may be nice, but sex
won't rot your teeth.

> *dental hospital,*
> *London*

*P*LEASE DON'T WRITE ON WALLS
- you want maybe we should type?

*V*ote TGWU at the next General Election and cut out the middle man.

Croydon, 1979

*M*ARGARET THATCHER SHOULD BE P.M.
- yes, permanently muzzled.

Sheffield

*G*et Maggie Thatcher before she gets . . . ugh . . .

Exeter

*T*HE GRAFFITI IN THIS PUB IS TERRIBLE
- so is the shepherd's pie.

*F*ree the Inter-City 125.

Paddington

*O*n baffling wall-map of
flyovers and tunnels, during
reconstruction of Liverpool city
centre, someone had added:
Throw six to start.

*T*ime flies like knives, fruit flies
like bananas.

Corsham

*N*ever mind the Titanic - is there
any news of the iceberg?

WORLDS FIRST SEE -
THROUGH TOILET

Keele University

GRAFFITI

Owing to lack of interest,
tomorrow has been cancelled.

*Wisconsin
University*

TOURISTS, YES
TROOPS NO

Dublin

ADVANCE TOWELMASTER
- and be recognised.

Anarchy, no rules, OK?

Kentish Town

MORE FEMALE TRAIN
DRIVERS
- a woman's right to choo-choose

*Hampstead Heath
station*

I AM A PRACTISING
TRANSVESTITE ON
HOLIDAY HERE TILL NEXT
WEEK. IF YOU WOULD LIKE
TO MEET ME I WILL BE
HERE AT 7.30 EACH NIGHT
- how will I recognise you?

> *Welsh seaside*
> *resort*

O, weary traveller, do not weep
They are not dead - just fast
 asleep.

> *scribbled on*
> *restaurant menu,*
> *Irish Republic*

*I*s John Travolta the new
Eminence Grease?

*A*lice Trout moves mysteriously.

BEAT UNEMPLOYMENT
-VOTE LABOUR
- Vote Conservative and treat it
nicely.

Corby

Fight unemployment - waste
police time.

If you can do joined up, real
writing, you too can be a union
leader.

Canvey Island

UNORFADOX.

Blackwall Tunnel

May all your ups and downs be
in bed.

Reno, Nevada

Yea, though I walk through the valley of death I will fear no evil, for I am the biggest son of a bitch in the valley.

I am a vampire. Please wash your neck.

*gents' lavatory,
Manchester*

A *few years ago, Birmingham carried out an anti-vandalism campaign. Someone helping to spread the message had removed the small mosaic links from the mural in a city subway so that is read:*
HELP STOP THE VANDAL

Anagrams - or luke?

Pavlov's Dogs rule.

All Souls boot boys rule, OK.

Oxford

Are you a schizo? - if so that makes four of us.

God made things that creep and crawl
But British Rail, it beats them all.

Harrow station

MEN SPREAD V.D.
ONLY IF WOMEN HELP

But for venetian blinds it would be curtains for all of us.

Dublin

Verdi is alive and well and living in Croydon.

Royal College of Music

Give Vietnam back to the Irish.

Harrow

I'VE LOST MY VIRGINITY - have you still got the box it came in?

To all virgins - thanks for nothing.

church institute, Buckingham

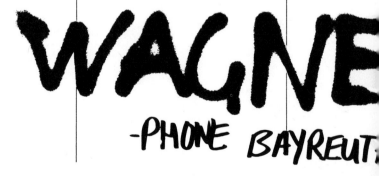

*T*here will be a meeting for all the virgins in the telephone box at 4 p.m.

> *girls' lavatory,*
> *Sussex*
> *comprehensive*
> *school*

*V*irginity is like a balloon - one prick and it's gone.

> *ladies' lavatory,*
> *Leicester Square,*
> *London*

*T*HE WAGES OF SIN IS DEATH
- if you have already paid, please ignore this notice.

> *Much Wenlock,*
> *Shropshire*

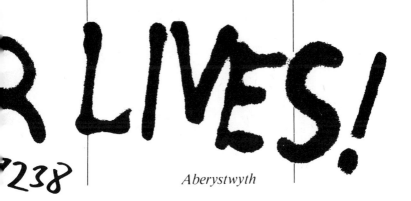

> *Aberystwyth*

WE HAVE WAYS OF MAKING YOU WALK

in bus garage

GRAFFITI

*E*veryone writes on the walls but me.

> *Pompeii,* AD *79*

DIONNE WARWICK FOR POPE

*D*o your best - Birmingham needs the water.

> *gents' lavatory,*
> *North Wales*

*S*chrödinger rules the waves*

> *Nottingham*
> *University*

*Erwin Schrödinger (1887-1961), Austrian physicist who developed the theory of wave mechanics.

211

*J*OHN WAYNE DEAD

> *newspaper*
> *placard, 1979*

- the hell I am!

I used to be
I'm all rgh

*W*hat's up, Doc?

> *addition to*
> Watership Down
> *film poster*

*W*HO IS THY NEIGHBOUR?

> *wayside pulpit,*
> *Stockport*

- Him and his Daleks.

*I*t is forbidden to lean out of the window.

> *by cell window,*
> *Middlesex*
> *Guildhall*

212

GRAFFITI

Were wolf - but nowoooooooo!

Manchester

I look better on a woman.

A woman without a man is like a moose without a hatrack.

Canada

Women were born without a sense of humour - so they could love men and not laugh at them.

Amsterdam

END VIOLENCE TO WOMEN NOW
- yes, dear.

Wandsworth

SUPPORT
LIE
GET
FROM

*T*ypographers rule, OQ.

*W*ords do not mean *anything* today.

London NW3

214

WOMEN'S OUT NNDER

*D*on't go to work - there's a lot to do.

York

*D*ouble your pleasure, double your fun - Xerox your pay cheques.

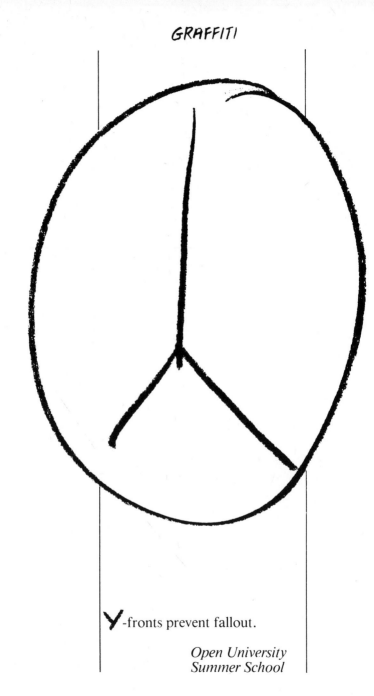

Y-fronts prevent fallout.

Open University
Summer School

Xerox your life - if you lose it, it's nice to have a copy.

London SW1

No hand signals - driver eating Yorkie

*on lorry in
Cheltenham*

Town criers rule, okez, okez, okez.

Corby

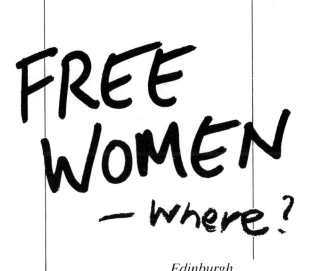

Edinburgh

I QUOTED MARK IN
MY FINALS AND FAILE

—

I QUOTED CARLYLE IN
MY FINALS AND
 FAILED

—

I QUOTED THIS
WALL IN MY
 FINALS AND
 PASSED

Beware of bathroom walls.
That've not been written on.
> *Bob Dylan,*
> *'Advice for*
> *Geraldine on her*
> *Miscellaneous*
> *Birthday'*

The words of the prophet are
Written on the subway halls
And tenement walls.
> *Paul Simon,*
> *'Sound of Silence'*

There's many an airman has
blighted his life.
Thro' writing rude words on the
wall.
> *Jimmy Hughes*
> *and Frank Lake,*
> *'Bless 'em all'*

*R*ED ARROWS FLYING
DISPLAY
– if wet, in Town Hall.
Fowey

*W*hy is it that the only people
who know how to run our country
are either driving cabs or cutting
hair?
Vancouver, B.C.

*T*his film contains scenes of
explicit sexual interhorse.
on Equus *poster,*
London

ALL THE BIG
WOMEN DIG YOUNG
THAT'S WHY WE'RE
LEFT WITH LITTLE
OLD LADIES.
Paris

*G*ive peace a aah-argh!
Covent Garden

My heart aches and a drowsy
numbness drains my sense as
though of hemlock I had drunk.
Signed: a British Rail tea victim.
*King's Cross
station, London*

THE ECONOMY IS THE
SECRET POLICE OF OUR
DESIRES
Swiss Cottage

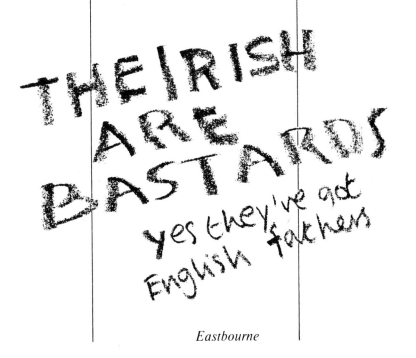

Eastbourne

*I*s a tramp without legs a low down bum?

Worksop

*I*ci s'écroulent en ruines
Les triomphes de la cuisine.

*written in the
outside loo of the
composer
Constant Lambert*

*T*HIS IS THE AGE OF THE TRAIN
– ours was 104.

*Paddington
Station, London*

*K*EEP AUSTRALIA GREEN
– have sex with a frog.

Sydney

222

*T*he young man who was asked by Joyce McKinney to marry her replied that he was too young to be tied down.

London W1

*D*ada wouldn't buy me a Bauhaus.

Norwich

*P*ARIS EVERY SPRING
JEANS EVERY WEEKEND
DAILY MAIL EVERY DAY
– Valium every night.

London WC1

*L*ENNY IS A STUPID FAGET
– I may be stupid but at least I can spell fagget.

New York

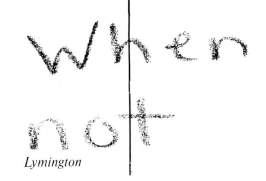

Lymington

*T*his door will shortly be
broadcast on Radio 4.

*on door of ladies'
lavatory,
Newcastle-upon-
Tyne*

O.H.M.S.-

INTERES

ECONOM

PLEASE US

SIDES O

Nothing succeeds like a parrot.
Worksop

N THE
OF WAR

BOTH
HE PAPER

gents' lavatory
Whitehall, Second
World War

*D*octor: I am afraid you are suffering from Alice.
Patient: What's that?
Doctor: We don't really know, but Christopher Robin went down with it.

*Leeds Hospital
Medical School*

*V*IOLEZ VOTRE ALMA MATER.

Nanterre, 1968

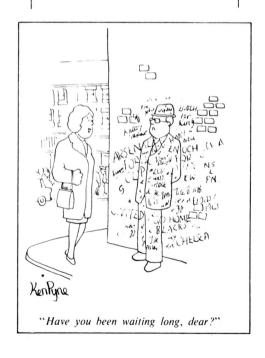

"*Have you been waiting long, dear?*"

226

*S*ock it to me with apathy.
> *Boston, Mass.,*
> *1969*

*A*phorism is the death-rattle of
the Revolution.
> *Balliol College,*
> *Oxford, 1968-9*

*R*izla Skins Roll OK.
> *University of*
> *Leeds*

IF GOD EXISTS THAT'S HIS PROBLEM

> *Edinburgh*

227

HOMES

RETIRED

At this moment you are the only man in the army who knows what he's doing.

*gents' lavatory,
Aldershot*

FoUow the
Little Arrows

*instruction in
gents' lavatory,
Taunton.*

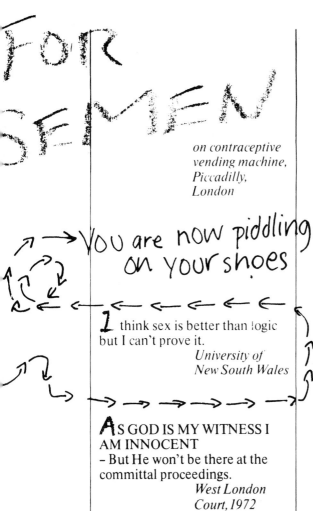

FOR SEMEN

*on contraceptive
vending machine,
Piccadilly,
London*

YOU are now piddling
on your shoes

I think sex is better than logic
but I can't prove it.
*University of
New South Wales*

AS GOD IS MY WITNESS I
AM INNOCENT
– But He won't be there at the
committal proceedings.
*West London
Court, 1972*

Adam met Eve and turned over
a new leaf.
Broadstairs

229

*I*N CASE OF ATOMIC
ATTACK:
1. PUT YOUR HANDS OVER
YOUR EARS.
2. PUT YOUR HEAD
BETWEEN YOUR LEGS.
3. KISS YOUR ASS GOODBYE.
San Francisco

*I*N SIX DAYS THE LORD
MADE HEAVEN AND EARTH,
THE SEA, AND ALL THAT IN
THEM IS
– he was self-employed.
Maldon

*A*VE MARIA
– I don't mind if I do.
Nottingham

*B*ALLS TO BALLS
Cambridge

*R*epeal the Banana.
Melbourne

*T*heda Bara is a form of Arab Death.

Chicago

*T*he BBC has always been 50 years old.

*during
anniversary
celebrations, 1972*

*D*on't complain about the beer. You'll be old and weak yourself one day.

Oxford pub

*J*oe Jordan kicks the parts other beers don't reach.

Northolt

*D*o you think that because of the element of uncertainty introduced into quantum theory by wave mechanics that there will be an ultimate limit to human knowledge? Courtesy of Sophisticated Graffiti Inc.

Moffat, Scotland

Why not buy 144 and be grossly oversexed?

on contraceptive vending machine, Blackpool

*W*ARNING. BERLIN POLE
VAULTERS' TRAINING
GROUND

on Berlin Wall

*H*ere's to the cut that never
heals, The longer you stroke it,
the softer it feels.
You can wash it in soap, you can
wash it in soda,
But nothing removes the
Billingsgate odour.

*during Second
World War,
West Midlands*

*B*RING BACK THE BIRCH
– please!

London NW1

*B*LACK POWER
– is it cheaper than gas?

Brixton

*J*ust gone for a walk round the
block. Anne Boleyn.

Hull

*S*ee the Atomic Blonde!!
Blasted into maternity by a
guided muscle!!

London W1

WITH BOOZE
YOU LOSE
WITH DOPE
YOU HOPE
BLOW YOUR MIND —
SMOKE GUNPOWDER

Harwich

Jesus jogs.

*Camperdown,
N.S.W.*

Persuasion rules OK –
just this once!

Brighton

*I*f I said you had a nice body,
would you hold it against me?
Worksop

STAN BOWLES HAS LAID ON MORE BALLS THAN FIONA RICHMOND

Fulham

*I*f you don't vote for me, I'll hold
my breath.

*on Shirley Temple
Black election
poster, 1960s*

YOU CAN
TELL
A BRITISH
WORKMAN
BY HIS HANDS.....
they are always in his
pockets

Westfield College,
Hampstead

BURGERS IN BERKSHIRE
WINE IN WILTSHIRE
COFFEE IN CORNWALL
> *British Rail*
> *catering poster,*
> *to which had*
> *been added:*

– Sick in Southend.

ONE IN KATE BUSH IS WORTH TEN IN THE HAND

Bristol

Do not bend, fold, staple or
mutilate in any way this wall.
> *Wisconsin*

Cambridge, give me back my
mind.
> *Cambridge*

*T*he sexual urge of the Camel
Is greater than anyone thinks.
After several months on the
desert,
It attempted a rape on the
Sphinx.
Now, the intimate parts of that
Lady
Are sunk 'neath the sands of the
Nile.
Hence the hump on the back of
the Camel
And the Sphinx's inscrutable
smile.

> *artillery camp,*
> *Cairo, 1940*

*T*HICK CARROT SOUP IS
BEST

> *Lambeth Bridge*

JIMMY CARTER HAS SMALL NUTS

> *Worksop*

*E*ARN CASH IN YOUR
SPARE TIME
– blackmail your friends.

> *Manhattan*

No to

Racial

Send the

back

Siyned

ROCK AGAINST RACISM
– Nihilists against everything.
Eastbourne

Multi-
Society
Angles
A Cdt

Brent Cross

More people died at
Chappaquiddick than at Three
Mile Island.

New York, 1980

241

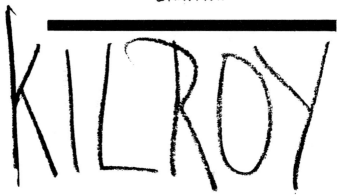

*E*ric Partridge in his *Dictionary of Slang and Unconventional English* quotes a clipping from the *San Francisco Chronicle* of 2 December 1962: 'Two days before the Japanese attack on Pearl Harbour, an unimposing, bespectacled, 39-year-old man took a job with a Bethlehem Steel Company shipyard in Quincy, Mass.

'As an inspector...James J. Kilroy began making his mark on equipment to show test gangs he had checked a job. The mark: "Kilroy was here."

'Soon the words caught on at the shipyard, and Kilroy began finding the slogan written all over the installation.

'Before long, the phrase spread far beyond the bounds of the yard, and Kilroy – coupled with the sketch of a man, or at least his nose peering over a wall – became one of the most famous names of World War II.

'When the war ended a nation-wide contest to discover the real Kilroy found him still employed at the shipyard.

'And last week, James Kilroy...died in Boston's Peter Bent hospital, at the age of 60'. Stuart Berg Flexner in *I Hear America Talking* states

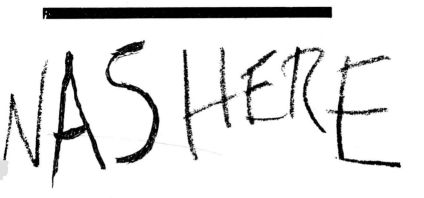

confidently that the phrase had begun to appear in a few docks and ships and in large ports in late 1939 and was well established by 1942.

Partridge also offers a rival theory, quoting from another (1945) newspaper clipping:

'The phrase originated in the fact that a friend of Sgt Francis Kilroy thought him a wonderful guy and scrawled on the bulletin board of a Florida air base, "Kilroy will be here next week". The phrase took the fancy of army fliers and it spread across the world'.

There is no doubt in my mind that 'Kilroy' is of American origin. Quite what he stands for or stood for is another matter. William Safire in his *Political Dictionary* speaks of the name as a 'sobriquet for the American soldier who – in every battleground and staging area of World War II – "was here" '.

Bemoaning the decline of the sobriquet in political life, Safire wonders, 'Was Eugene McCarthy getting close to the national mood when he wrote a poem about the disappearance of "Kilroy"… [hinting] that the disappearance of "Kilroy" meant the disappearance of pride?'

Peals of laughter
Screams of Joy
I was here before Kilroy.

Shut your mouth. Shut your
face, Kilroy built the ruddy
place.

Gents, Tring

Sing and shout
And dance with joy
For I was here before Kilroy.

Alas, my friend, before you
spoke, Kilroy was here, but his
pencil broke.

Portmeirion

Have wife, must travel.
on back of lorry

We the willing, led by the
unknowing, are doing the
impossible for the ungrateful. We
have done so much for so long
with so little, we are now
qualified to do anything with
nothing.

*Ninth Precinct
police station,
New York*

Masturbation is great – and you don't have to take your hand out to dinner afterwards and talk to it about its problems.

> *gents' lavatory,*
> *London W1*

BRING YOUR CHILDREN TO LONDON

> *British Rail*
> *poster,*
> *Manchester*

– And leave the little buggers there.

GO TO CHURCH ON SUNDAY AND AVOID THE CHRIST-MAS RUSH

> *Horncastle*

Cisterns of the world unite – you have nothing to lose but your chains.

> *Tunbridge Wells*

Last Coke for 3,000 miles.

> *on Berlin Wall*

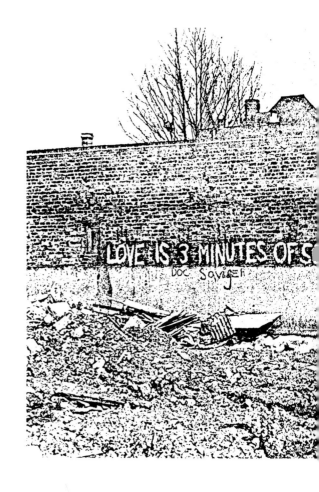

246

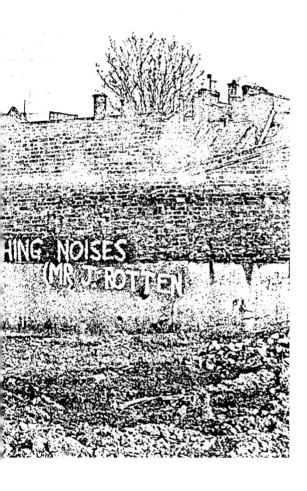

JESUS LIVES
– does this mean we won't get
an Easter holiday then?
Bristol

VOTE COMMUNIST
– Remember Hungary
– Remember Czechoslovakia
– Remember the spelling
– Tanks for the memory.
Otley

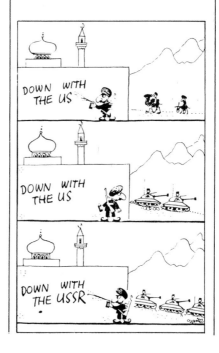

DOWN WITH PROTESTS
– up with graffiti.

New York

WORST CHEWING GUM
I'VE EVER TASTED

*on contraceptive
vending machine*

– Oh, but what bubbles!

CONFUCIUS HE
SAY: WHLST CHAIN
SWING, SEAT WILL
BE WARM

Bath

*B*eware! Jacques Cousteau filming.

ladies' lavatory,
BBC

I don't think crazy paving is all it's cracked up to be.

Leighton Buzzard

*T*he DC10 is not all its cracked up to be.

Gatwick Airport

*C*rime is the highest form of sensuality.

London W11

*W*as Danny La Rue the last woman to hang?

Worksop

*T*imothy Davey got six years for peddling shit.
Lew Grade got a knighthood for it.

Elstree

MORE DEVIATION LESS POPULATION

Miami Beach

DISARM TODAY—
PAT ARM TOMORROW

Stafford

DIDDUMS WILL GET BOUNCED

Durham

251

Anti-social diseases are a sore point.

Birmingham

Beat inflation. Inflation. Eat the Rich.

Sydney

OK sauce rules, HP

Hitchin

Q. Why is semen white and urine yellow?
A. So an Irishman can tell whether he's coming or going.

Fulham

You'll believe a woman can fly.

on Bedknobs and Broomsticks *poster*

MORDEN
– enough.

*London
Underground
map*

We are the writing on your wall.

*at 144, Piccadilly
London, when
taken over by
squatters*

LITTLE RED
RIDING HOOD
IS A RUSSIAN
CONTRACEPTIVE

*Museum station,
Sydney*

OH, VERY WITTY, VERY CLEVER ALL YOU GRAFFITI WRITERS, SOME REALLY GREAT MATERIAL, BUT HAVE YOU EVER STOPPED TO THINK WHO HAS TO CLEAN THIS MESS UP? NO, OF COURSE, YOU HAVEN'T BUT LET ME TELL YOU ITS VERY HARD WORK AND TAKES A HELL OF A LONG TIME. SIGNED: an Overworked Council Worker

written among
much other graffiti
on a wall in Bootle

*W*hat is the difference between
God and Father Christmas?
There is a Father Christmas.
Dublin

*T*HIS CISTERN IS FITTED
WITH DOLBY
– takes the slush out of flush.
– takes the hiss out of piss.
Leeds

СВЕРХУ МОЛОТ
СНИЗУ СЕРП
ЭТО - НАШ
СОВЕТСКИЙ ГЕРБ
ХОЧЕШЬ-ЖНИ,
А ХОЧЕШЬ КУЙ,
ВСЁ РАВНО
ПОЛУЧИШЬ,
ХУЙ!

Rough translation
Below – the sickle
Above – the hammer:
This is the seal on our Soviet
banner.
Whatever in life
You choose to do,
It's all the same:
You'll still get screwed.
Moscow, 1966

LIGHT EMBASSY, THE

*W*hat's the difference between
E.M.I. and the Titanic?
The Titanic had a better band.
London W1, 1979

*H*ow will I know if I'm
enlightened?
London W11

*A*ll this graffiti is too heavy!
Why doesn't anyone write about
bunny rabbits?
*Sussex
University*

*Liverpool Street
Station, London*

*E*skimos are God's frozen
people.

Greenwich

*F*UCK YOUR ETHNIC GROUP
– Yassuh!

New York

*E*ve was framed.

> *ladies' lavatory,*
> *Dublin*

*I*s euthanasia justified in the case of Dutch elm disease?

> *Cambridge*

*Y*es! Everything was so different before it all changed.

> *Newcastle-upon-*
> *Tyne*

*F*AITH CAN MOVE MOUNTAINS – she's a big girl.

> *Corsham*

*T*HE FAMILY THAT PRAYS TOGETHER STAYS TOGETHER – thank God my mother-in-law's an atheist.

> *Los Angeles*

*P*lumbers don't die, they just go down the drain.

> *Cromer, N.S.W.*

*G*od give me patience – but
hurry please!

London W1

W.C. Fields is alive and drunk
in Philadelphia.

Philadelphia

*C*ome home to a real fire – buy a
cottage in Wales.

Swansea, 1980

*F*ireraisers of the world ignite!
Hampstead

*W*ho took the fizz out of physics?
Cambridge

fly the flag:
HANG A MOD!
Streatham

*F*lags today – gas masks tomorrow.
Chelsea,
observed by Vera
Brittain at the
time of George V's
Silver Jubilee,
1935

*Y*ou can't fool all of the people all of the time, but if you do it just once it lasts for five years.
British Museum

*I*t is forbidden to forbid.
Paris, 1968

*F*ree persons everywhere.
Covent Garden

STAMP OUT
VANDALISM
OR I'LL
BREAK
YOUR
WINDOWS
Sutton

Why not an actor? We've had a clown for four years.

New York, 1980

Q. WHATS THE DIFFERENCE
BETWEEN AN EGG AND
A WANK.
A. YOU CAN'T BEAT A
WANK

Cardiff

GOD WILL PROVIDE
– only God knows if there is
a God.
– God only knows if there is
a God.

Birmingham

Equality is a myth. Women are better.

*N.S.W. Institute
of Technology*

FREE WALES
– from the Welsh.

Newport, Dyfed

*I*f the French won't buy our
lamb we won't use their letters.
> *on back of*
> *motorway*
> *juggernaut,*
> *during 'Lamb*
> *War,' 1980*

THERE IS NOTHING
SO OVERRATED
AS A BAD
FUCK
AND NOTHING SO
UNDERRATED
AS A
GOOD SHIT.

> *Ottawa*

ANYWHERE, PROVIDING
IT BE FORWARD
- The Gadarene Swine
> *church wayside*
> *pulpit*

*G*ASCOIGNE PEES

> *estate agents'*
> *notice-board,*
> *Woking*

– don't we all?

*I*s a lesbian a pansy without a stalk?

> *Sheffield*

CITY
PLANNERS
DOIT WITH
THEIR
EYES
SHUT

> *Bath*

*T*here's no future in being gay.

> *Lincoln*

I am bi-sexual. If I can't get it I buy it.

London W1

OLD GOLFERS NEVER DIE THEY SIMPLY LOSE THEIR BALLS.

Coventry

SHAKE HANDS WITH YOUR BEST FRIEND
– Shake hands with the unemployed.

*gents' lavatory,
Sydney*

The most common graffito of the past forty years, apart from 'Kilroy was here' (although it is sometimes found in conjunction with that phrase), is the so-called Chad – also known as 'Mr Chad' or 'The Chad'.

In Britain at least, it is generally accepted that Chad made his first appearance in the early stages of the Second World War, accompanied by comments or protests about shortages of the time such as

'WOT, NO CAKE?'
'WOT, NO CHAR?'
'WOT, NO BEER?'

The questions one would dearly like to see answered are: How did Chad arise? Why does he have this particular form? And why is he called Chad? Looking for answers to these questions is fun, though a definitive explanation of the origin of Chad is about as likely as a definitive explanation of 'Kilroy was here'.

he matter is further complicated by the fact that in the United States the picture of Chad has often been accompanied by the phrase 'Kilroy was here' or

'WOT, NO KILROY?'

In the U.K., however, the two have generally appeared separately. It is tempting to suggest that, if Kilroy was imported from the U.S., Chad was exported from the U.K.

ccording to a newspaper cutting dated 17 November 1945 quoted in Eric Partridge's *Dictionary of Slang and Unconventional English,* Chad, 'the British services counterpart of Kilroy,' was known variously as 'Flywheel, Clem, Private Snoops, the Jeep, or Phoo' (the latter particularly in Australia). Elsewhere in the *Dictionary,* Partridge says that 'Foo' was the Australian equivalent of Kilroy.

lem' appears to have been a Canadian version of Chad or Kilroy. A story is told of an army post where all the men were told by their commanding officer that if the name Clem was inscribed anywhere again they would be severely punished. When he returned to his office, he found scrawled on the wall

"WOT, NO CLEM!?"

In Britain, one widely held view of Chad's peculiar form is that it began with an army or airforce lecture on electronics or radar. The lecturer drew on a blackboard the effect of a condenser on a circuit:

(RESISTANCE) (CONDENSER) (RESISTANCE)

He then drew a positive electrical sign on one plate, a negative one on the other, and explained that if you shorted the plates, it was equivalent to joining the two near ends of the resistors together, like this:

Some unknown hand added the single curled wisp of hair and inscribed underneath:

'WOT, NO ELECTRONS'

all of them having been discharged.

Another, similar explanation of Chad's face is that it grew out of a drawing of alternating current wave form:

The lecture is variously said to have taken place at Gainsborough, Lincolnshire, Hednesford, Staffordshire, Bolton or Blackpool. Whichever was the actual location of this great moment of popular creativity, to me it seems a feasible, if somewhat elaborate theory.

Why did the little man end up being called Chad? One correspondent who attended the Junior Technical School run from a building in Manchester Road, Bolton, suggests that service personnel attended courses at the college and the Women's Auxiliary Air Force (the WAAFs) had links with a building known as Chadwick House, which might have had something to do with the choice of name and with what the lad was looking at... A diverting piece of information comes from the same correspondent: he says the doodle became notorious after it was discovered at the scene of a serious crime and was suspected of having been scrawled there by the perpetrator.

The solution I should like to believe is that the name comes from the film *Chad Hanna,* starring Henry Fonda and Linda Darnell as a couple who run off to join the circus in mid-nineteenth-century America. I sat through the film recently in the hope that the Fonda snout would project longingly over a fence at some stage – but no, it doesn't. Even so, the film was released in Britain in June 1941 – at the very time the doodle first appeared.

H.M. Government Warning:
Sandra G****Spoils Your Health.
> *on 16A London
> bus*

*T*hese days govt. is a four-letter word.
> *Denver*

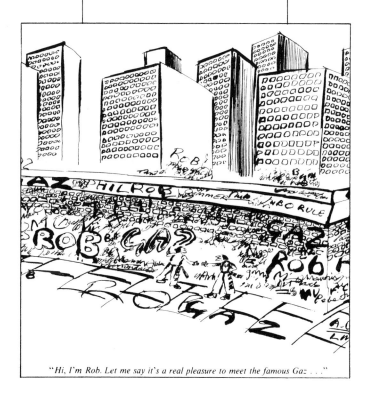

"Hi, I'm Rob. Let me say it's a real pleasure to meet the famous Gaz . . ."

Graffiti's days are numbered –
the writing is on the wall.
Colchester

what did

irish

his pet

Vaseline makes the coming easy.
And the going back.
Oxford

the
man call
zebra?
spot!

Dunstable

273

HASHISH TO HASHISH, LUST TO LUST, IF THE GRASS DON'T GET YOU, THEN ACID'S A MUST

Harrow station

*C*ourage reaches the parts other beers don't bother with.
York

GRAFFITI

*Y*our family's future lies in your hands.

gents' lavatory,
traditional

*H*ang the extremists.

University of
Lancaster

*H*ELP THE AGED WALK
– give 'em crutches.

Leamington Spa

*H*issin Sid loves Monty
Python – he's a puff adder.

on lorry in
London

I LOVE MARGARET
HOLMES
– Good Lord, Watson, so do I!

Liverpool

I'm so horny the crack of dawn
had better watch it!

Dover

275

INCEST—

THE WHOLE

CAN PLA

DON'T THRO

IN THE TOIL

THEM SOGG

GAME

FAMILY

CIGARETTES

+ MAKES

AND DIFFICULT

*T*he horses of instruction *are* greater than the tigers of wrath.*
> *Euston Square*
> *Underground*
> *station*

**B*lake, Proverbs of Hell, '*The tigers of wrath are wiser than the horses of instruction*'.

YOUNG MAN,
WELL HUNG,
WITH BEAUTIFUL
BODY IS
WILLING TO DO
ANYTHING.

P.S. IF YOU SEE THIS, BILL,
DON'T BOTHER TO CALL,
IT'S ONLY ME, TONY.
> *New York*

*C*all it incest – but I want my mummy.
> *Glasgow*

I thought that an innuendo was an Italian suppository until I discovered Smirnoff.

Trafalgar Square
Underground station

*N*O ALCOHOL IN IRAN BUT YOU CAN GET STONED ANY TIME –
and the Ayatollah Khomeini will shake you warmly by the stump.

London WC1

J.R. is the Fifth Man
London, 1980

J. R. NEVER GOT SHOT – HE WAS ONLY ACTING

London, ditto.

*J*ohnny is only rotten.
Elvis is decomposing.

Chelsea, 1980

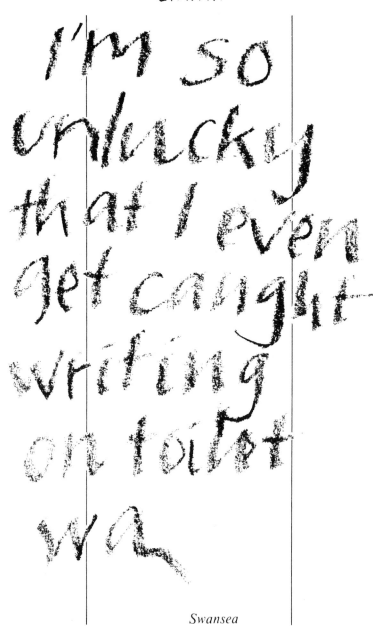

I'm so
unlucky
that I even
get caught
writing
on toilet
wa

Swansea

280

*I*f people from Hemel
Hempstead get haemorrhoids, do
people from Poland get Polaroids?
Hemel
Hempstead

*O*nly his hairdresser knows for
sure.
New York

*G*enitals prefer blondes.
Leeds

*B*eautiful girls, walk a little
slower when you walk by me.
seen by Gordon
Jenkins in New
York City,
inspiration for
'This is all I ask'.

*W*as Handel a crank?
Taunton

*Y*our mind is like a Welsh
railway – one track and dirty.
Colchester

281

Q. What do you call a 6'6"
Angolan guerilla with a sub-
machine gun and six hand
grenades?
A. Sir!

> *Piccadilly,*
> *London*

*I*f the buses were on time we
wouldn't write on bus shelters.
> *Bath*

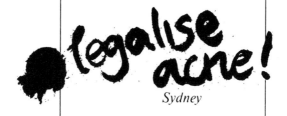

> *Sydney*

*I*nsert baby for refund.
> *on contraceptive*
> *vending machine,*
> *Oxford*

Do you realise if Kissinger was
shot today, Nixon would become
President?
> *Washington,*
> *1972*

*L*augh, and the world laughs
with you.
Cry, and you wet your face.
Worksop

*K*nock softly but firmly – I like
soft firm knockers.

*on door of Ford
transit van,
Gosport*

I WILL KNOKE OFF YOUR
WIFE OR GIRLFRIEND FOR
£5. TELEPHONE WELLS *****
– by knoke do you mean 'bump'
or 'bang'?
Please answer.

*gents' lavatory of
tea-rooms, Wells*

IF I HAD THE WINGS OF A SWALLOW
AND THE ARSE OF A BLOODY
GREAT CROW
I'D FLY TO THE TOP OF THE CROWN
COURTS
AND SHIT ON OLD LASKI BELOW

*referring to
Neville J. Laski
QC, Marghanita's
father, who was
once shown this
in a Crown
Court cell*

Sausage Rolls, OK
Brighton

Kilroy was queer.
Stamford

KING KONG DIED FOR OUR SINS

New York

A KING NEVER DIES
*Nottingham,
when Elvis Presley
died, amended,
when Bing Crosby
died, to*
A BING NEVER DIES

*W*ho rules the Kingdom? The King!
Who rules the King? The Duke!
Who rules the Duke? The Devil!

> *Seventeenth century, referring to George Villiers First Duke of Buckingham, favourite of King James I.*

*D*on't read this, you fool. Watch what you're doing.

> *gents' lavatory, Barnstaple*

*G*OD NIBBLES
– one does what He can.

> *Cambridge*

SAY NO TO LONDON'S THIRD AEROSOL

> *Finchley*

ALL WOMEN OVER 40 ARE
LESBAINS
– but they can spell.
Cambridge

BRIGHTON

– LEWES DECEN

Lesbians ignite!
Edinburgh

Life is biodegrable art.
London W11

Existentialism has no future.
Sydney

*T*hank God I'm an atheist.
Aberdeen

BOOT BOYS

OUNG CHAPS.

Lewes

*L*ove makes the world go down.
Hackney

*T*his is not a dress rehearsal. This is real life.
Eight-O Club,
Dallas

*L*IVERPOOL ARE MAGIC
– Everton are tragic.
Liverpool

*W*e've seen the tree Marc Bolan hit.
> *Teddington*

*E*lla Fitzgerald...Interesting!
> *Edinburgh*

*J*oin the Marines – intervene in the country of *your* choice.
> *Los Angeles*

*L*IFT UNDER REPAIR – USE OTHER LIFT
– this Otis regrets it's unable to lift today.
> *York*

*E*xamples rule, e.g.
> *Southport*

*T*REAT OTHERS AS YOU WOULD HAVE THEM TREAT YOU
– I can't. I'm a masochist.
> *Euston Station, London*

Masturbation is a waste of
fucking time.
Bungay

MAVIS BROWN REACHES PARTS MOST BEERS CAN'T REACH

Worksop

Since using your shampoo, my
hair has come alive. Signed:
Medusa.
Athens

SUPPORT MENTAL HEALTH OR I'LL KILL YOU

Detroit

Your face is like a million dollars
– all green and crinkly.
Denver

Where can you start a new
career at fifty?
– Become a Millwall hooligan.
Balham

Should mountain goats be
illegal?
Nottingham

When I
grow up
I shall
Graffiti
the Ceiling

on lavatory door,
Oxford Circus,
London

*I*F TYPHOO PUT THE 'T' IN BRITAIN
– who put the 'arse' in Marseilles?

Taunton

SCOTLAND RULES OK THE NOO!

Aberdeen

*T*HE MEEK SHALL INHERIT THE EARTH
– they are too weak to refuse.

Kirkcaldy

*T*HE MEEK SHALL INHERIT THE EARTH
– but not its mineral rights.*

*J*ESUS SAVES
– Green Shield Stamps
– He's a redeemer too.

Poole

a saying sometimes attributed to J. Paul Getty

*V*ICI, VENI, VD

Birmingham

*B*E ALERT

- your country needs lerts.
- no, Britain has got enough lerts
now, thank you. Be aloof.
- no really, be alert. There's safety
in numbers.

Hampstead

*O*NE WOULD THINK FROM
ALL THIS WIT
THAT SHAKESPEARE
HIMSELF CAME HERE TO
SHIT

- And this my friend may well be
true.
For Shakespeare had to do it, too.

London, EC4

*W*HAT ARE YOU LOOKING
UP HERE FOR? ARE YOU
ASHAMED OF IT?

- No, I'm trying to look over it.

Fort William

*W*OMEN'S FAULTS ARE MANY
MEN HAVE ONLY TWO;
EVERYTHING THEY SAY
AND EVERYTHING THEY DO
– We men have many faults,
Poor women have but two:
There's nothing good they say
And nothing right they do.

Blackpool

*O*h do not touch me

„ „ „ „
„ „ „
„ „
„

Carshalton

TOLKIEN
HOBBIT

SO IS DILDO

294

MADE IN THE UK
*on contraceptive
vending machine*
- so was The Titanic
- yes, but who wants to fuck
icebergs?
Letchworth

GOSSAMER LUBRICATED
contraceptive slogan
- So was the Titanic.

EINSTEIN RULES
RELATIVELY, OK
- well, in theory anyway.
London, SE6

LIONS 7, CHRISTIANS 0
- Christians in heaven, lions ill.
Trier

London, W1

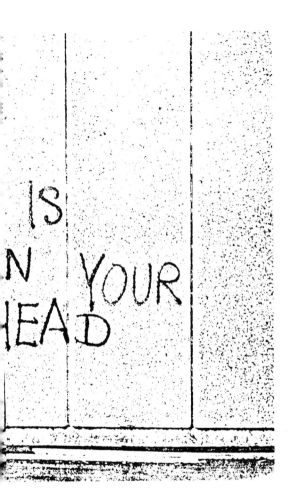

*W*hat's behind the National Front?

Hampstead

*W*ORK–BUY–CONSUME–DIE

Wandsworth

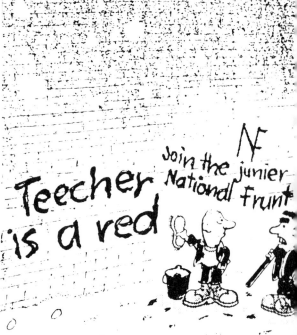

Teecher is a red

Join the junier National Frunt

HE SAYS WE CAN COME BACK F

I thought nausea was a novel by Jean-Paul Sartre until I discovered scrumpy.

University of Exeter

I was a necrophiliac until some rotten cunt split on me.

Soho

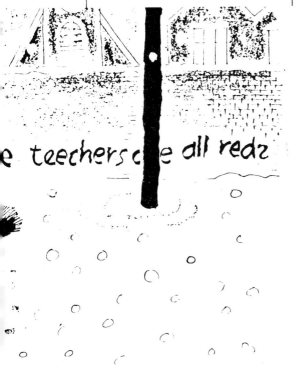

e teechers c e all redz

ERJA WHEN WE'VE SCRUBBED IT OFF.

*L*OVE THY NEIGHBOUR
– regularly.

Clapham

Does the
Netherlands
Royal Family
suffer from
Dutch Realm
Disease?

Amsterdam

1978 makes 1984 look like 1967.

Clerkenwell

Forget the notes and play the music.

Edinburgh

Nothing Beats the great Smell of Brut

— then why not use nothing?

Soho

*N*ottingham Forest wipes the floor with Ajax.

Nottingham, 1980

*N*udists are people who wear one-button suits.

Sheffield

*W*omen should be obscene and not heard.

Hertford

*O*edipus was the first man to bridge the generation gap.

New College,
Oxford

*O*pen this end, Paddy.

with a large arrow
pointing to the
rear of an Irish
articulated lorry

*S*upport wild life – vote for an orgy.

Oxford

*O*rville was also Wright.

Bristol

*P*lease pass – driver on overtime.

in dust on lorry

*H*ands off Cubal.

*a popularl
graffitol from
Bristol*

*S*TOP PASSENGER AS YOU
PASS BY
AS YOU ARE NOW SO ONCE
WAS I.
AS I AM NOW SO YOU WILL
BE
SO BE PREPARED TO
FOLLOW ME.

*gravestone at
Anworth,
Gatehouse of Fleet*

– To follow you I'd be content
If I only knew which way you
went.

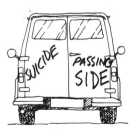

*in dust on back
of van*

*P*atrons are requested to remain
seated throughout the
performance.

gents' lavatory,
Leominster

MEN WHO
PUT
ON
RARELY
THEM

I used to dress off the peg, but now the neighbours take their washing in at night.

Irvine, Ayrshire

*N*o matter how you shake your peg. The last wee drop runs down your leg.

traditional

WOMEN

PEDESTALS

KNOCK

OFF

ladies' lavatory,
Charing Cross

You don't come here to sport
and play
But when you've done go straight
away.

gents' lavatory,
Crewe

JESUS LOVES
BLACK AND WHITE
(but he prefers johnny
Walker!)

Bath

The penis is mightier than the
sword.

Cambridge

La différence entre les sexes
n'existe pas.
Les femmes pètent aussi.

Caen

ST PETER'S SQUARE
– I know he is.

London W6

A woman is like a piano. If she's not upright she's grand.
Belfast

IF THE TORIES GET UP YOUR NOSE, THEN PICKET.

Liverpool

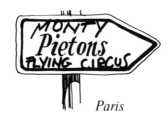

Paris

NEITHER SNOW NOR
RAIN NOR HEAT NOR
GLOOM OF NIGHT STAYS
THE COURIERS FROM THE
SWIFT COMPLETION OF
THEIR APPOINTED
ROUNDS

> *inscription from
> Herodotus on
> General Post
> Office, New York*

– well, what is it then?

Power corrupts – absolute
power is even more fun.
> *Brighton*

I'm not prejudiced – I hate
everyone.
> *Surbiton*

Old professors never die –
they simply lose their faculties.
> *Norwich*

*L*ife is like a pubic hair on a toilet seat – eventually you get pissed off.

Oxford

*D*rivers – don't pull out to avoid a child – you could fall off the bed.

M1 motorway cafe

*P*UNK IS DEAD
– no, it just smells that way.

Earls Court

*T*he guy at the front is the driver, not Quasimodo, so only ring the bell once.

London No. 29 bus

QUASIMODO -THAT NAME RINGS A BELL

Middleton St George

Q. What is the difference between a Radox bath and Louis Frémaux?

A. Radox bucks up the feet.

Birmingham

S oyez raisonnable, demandez l'impossible.

Cambridge, 1969

GIRLS, DON'T DRIVE MEN TO OFFER TO THE

*D*ISARM ALL RAPISTS
– it's not their arms I'm
worrying about.

> *Newmarket*

I AM NOT AN ANIMAL!
I AM A HUMAN BEING!

> *poster for film*
> The Elephant
> Man, *Turnham*
> *Green*
> *Underground*
> *station*

– I am Ronald Reagan!

ALIENATION!
YOURSELVES
REVOLUTION!

> *Paris 1968*

311

*W*HEN THE REVOLUTION
COMES WE'LL ALL DRIVE
ROLLS ROYCES
– what if we don't want to drive
Rolls Royces?
– when the Revolution comes you
won't have any choice.

Hemel
Hempstead

*J*OIN THE NATIONAL FRONT
– and help save Aintree
racecourse.

St Helens

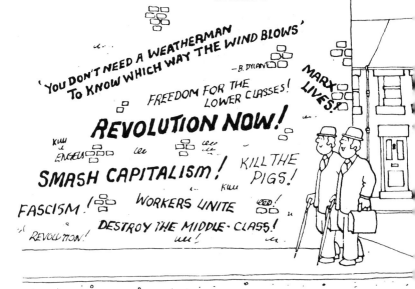

"DO YOU REALISE THAT IT'S
TEN YEARS TO THE
DAY SINCE WE WROTE ALL THAT?"

*T*oilet paper supplied by the Master of the Rolls.

Law Courts,
The Strand,
London

*L*IBERTÉ - ÉGALITÉ -
FRATERNITÉ
- Maternité.

Hospital, Paris

*I*N CASE OF FIRE DO NOT
ATTEMPT TO USE THE LIFTS
- try a fire extinguisher.

lift, University
College, Cardiff

It's 12" long
but I don't use
it as a rule

Berkhamsted

*G*ive sadists a fair crack of the whip.

Crawley

SAME THING
-TUBE, WORK
TUBE
T.V. SLEEP
HOW MUCH
YOU
ONE IN FIVE
ONE IN TEN

DAY AFTER DAY,
DINNER. WORK
ARMCHAIR,
TUBE. WORK –
MORE CAN
TAKE?
CRACKS UP.
GOES MAD.

Swiss Cottage
Underground station

315

*T*hanks be to God for finally
proving the non-existence of
Jean-Paul Sartre.

*King's College,
London, 1980*

*T*he S.A.S. smoke more
Embassies than Hurricane
Higgins.

Dunstable, 1980

*S*ave fuel – burn an Arab.

on back of lorry

*S*ex appeal – please give
generously.

Aston Clinton

*I*f sex is a pain in the arse –
you're doing it wrong.

Nottingham

*S*ex kills – die happy.

Orpington

*M*ore than three shakes is masturbation.

> *gents' lavatory,*
> *Glasgow*

*S*hetland Ponies Have Earlobes.
> *Vancouver, B.C.*

NO SIGNALS

EX NO.14

BUS

DRIVER

on lorry on M2

GRAFFITI

*B*ring back the Sixties.
> *California, 1980*

*S*KINHEADS ARE BASTED
– yes, indeed, they frequently are,
but wrapped in foil and slowly
roasted with just a hint of
marjoram in their own juices –
ah, what piquancy!
> *Essex Road*
> *British Rail*
> *station, London*

*S*kinheads have more hair than
brains.
> *Charing Cross*
> *Underground*
> *station*

*T*he trouble with political jokes
is they get elected.
> *Wolverhampton*

I asked the manager for a suite
with a view – he gave me a Polo
mint.
> *YMCA, London*

You, who write
upon this wall,
Whilst answering
your nature's call,
Why waste your
brilliant wit,
For you can
shine where
others shit

Calcutta Technical
School

ENGLISHMEN MAKE THE
BEST LOVERS
– the Japanese make them
smaller and cheaper.
London SW1

GUY

WHERE ARE

THAT WE

Working for the *******Bank is like smoking dope – the more you suck, the higher you get.
Holborn

FAWKES YOU NOW NEED YOU?

in dust on back of lorry

321

*I*n the United States, where even today the writing of a graffiti-artist's name is often more prevalent than any views he may have to express, there used to be a name to rank with those of Kilroy and Chad. William and Mary Morris in their *Dictionary of Word and Phrase Origins* recall that the name 'J B King' appeared on just about every piece of railroad rolling stock west of the Mississippi in the early part of this century. The name appeared in elegant script, omitting the full stops after the J and B, and all the letters were made with a single stroke of the chalk or crayon.

The Morrises received a letter not from any Mr J. B. King but from a Mr J. A. Abbott of St Joseph, Missouri, who claimed to have been the first to write this legend on freight wagons when he went to work for the railways in Atchison, Kansas. He said he took the signature from a handwriting manual. 'I went to work for the St Joseph and Grand Island (railroad) and, during World War I, put "J B King" on every piece of war machinery I could reach...recently [I] ran across a car on which I had written "J B King Esq 12.8.1914." It was pretty dim but could not be read, so I just put another right over it'.

Unfortunately the Morrises seem to have passed up the opportunity of asking Mr Abbott (if indeed he was the perpetrator) why on earth he did it.

*D*r Strangelove – or how I
learned to stop worrying and love
the bum.
> *Chelsea*

*S*tranger, stop and wish me well,
Just say a prayer for my soul in
Hell.
I was a good fellow, most
people said,
Betrayed by a woman all dressed
in red.
> *chalked on alley*
> *wall outside the*
> *Biograph Theatre,*
> *Chicago, just*
> *after John*
> *Dillinger, the*
> *gangster, was*
> *shot dead there,*
> *1934*

FEEL SUPERIOR–
BECOME A NUN!

> *New College,*
> *Oxford, 1966*

*E*lsie Tanner threw me out.
> *on back of lorry*
> *on M1*

*H*alf the girls at this college have TB, the other half have VD – so sleep with the ones who cough.

University of Durham

*K*eep your distance – sudden tea-breaks.

on back of Gas van seen in Leominster

*D*ESTROY THATCHER – not you, Sid.

on wall in picturesque Dorset village

*J*ust think – maybe the Joneses are trying to keep up with you.

Carshalton

Q. What do you get when you cross a vagina with a silicon chip?

A. A cunt that knows everything.

London W1

Support British Steel – smelt the Iron Lady.

Dumbarton, 1980

What's stiff and excites women? Elvis Presley.

Nottingham

Stop the world I want to get off.

appeared as a graffito before being used as the title of a musical

BEWARE RETREADS

on contraceptive vending machine, Cardiff

WHY IS MAN ON
THIS PLANET?
WHY IS SPACE
INFINET?
WHY ARE WE DOOMED?
WHY ARE YOU READING

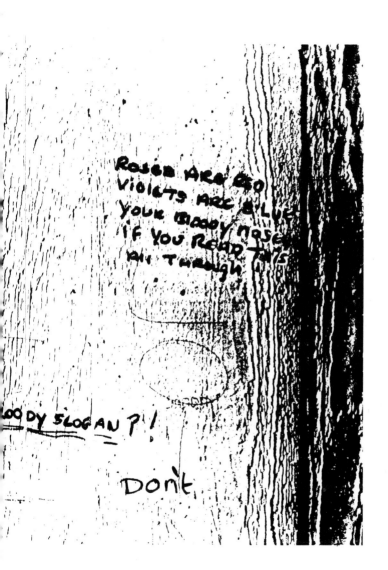

ROSES ARE RED
VIOLETS ARE BLUE
YOUR BLOODY NOSE
IF YOU READ THIS
ALL THROUGH

BLOODY SLOGAN?!

Don't

*W*hat is the difference between
God and Professor ********?
God is here but everywhere.
Professor ******* is everywhere
but here.

University of
East Anglia

*R*oses are red,
Pansies are gay,
If it weren't for kind ladies,
We'd all be that way.

Eastbourne

*T*his wall has now been reopened.

chiselled on wall
newly
pebbledashed
to prevent graffiti-
writing

*W*EARING THESE IS LIKE
PICKING YOUR NOSE WITH
RUBBER GLOVES ON

on contraceptive
vending machine,
Macclesfield
– My God, what a nose you've got!

GRAFFITI

WATCH THIS
SPACE
-why whats
it doing?

Hertford

329

*I*f you are not part of the solution
then you are part of the problem.
Oxford

*S*ave a whale – shoot a Nip.
Batley

*S*ODOM IS A SUMMER
FESTIVAL
– Gomorrah the merrier.
New York

IF you

you tinkle

wipe the

*H*urrah, hurrah, it's Spring,
The boid is on the wing.
How utterly absoid!
The wing is on the boid.
New York

*M*ake your MP work – don't re-
elect him.
Leicester

*M*utate now and beat the rush.
Los Angeles

sprinkle when

Be a sweetie,

eatie

*ladies' lavatory,
Totnes*

*P*ity the man with ambition so
small He writes his name on a
lavatory wall.
London EC3

GRAFFITI

*A*pathy rules, oh dear…
> *Bristol*

*B*efore the Thatcher
Government came to power we
were on the edge of an economic
precipice – since then we have
taken a great step forward.
> *Polytechnic of the*
> *South Bank,*
> *London*

*D*o not disturb, seeds planted.
> *in dust on a very*
> *dirty car,*
> *traditional*

*N*uclear power plants are built
better than Jane Fonda.
> *Philadelphia,*
> *1980*

*W*iggle your toes for sex.
> *gents' lavatory,*
> *Philadelphia*

*T*he only good Tory is a lavatory.
> *Blackpool*

THIS IS THE AGE OF THE
TRAIN
– it takes an age to catch one.

Paddington Station,
London

THE LAST
TRAIN RUNS
LATER
THAN YOU THINK
—why pick on
that one?

Charing Cross
Underground
station

in dust on
back of lorry

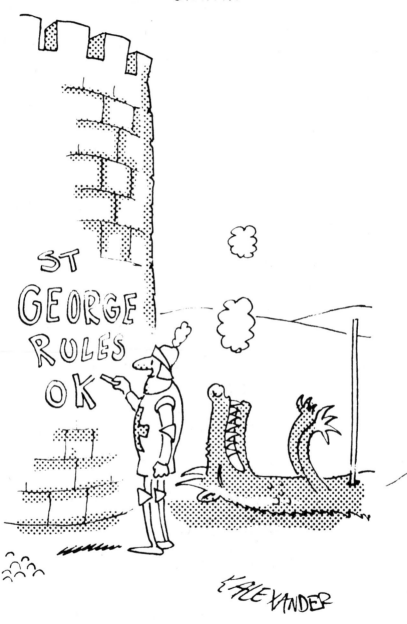

*U*nilateral withdrawal is the
answer to the population problem
Barnstaple

All this beer drinking will be the
urination of me.
Stamford

MEDICAL STUDENTS ARE ASKED TO PROVIDE A SPECIMEN OF URINE IN THE RECEPTACLE PROVIDED - PLEASE GIVE GENEROUSLY

*medical school
lavatory, London*

Visit the USSR before the USSR visits you.

London W1

VAMPI
AREA
IN THE.

VD is nothing to clap about.
ladies' lavatory,
Alaska

RES
PAIN
NECK

Scunthorpe

337

WHEN TWO
A RAILWAY
MAN EXPOSED
FAINTED AND
HAD A

There is no fury like a vested interest masquerading as a moral principle.

Hampstead

Help your local police cut out graffiti. Carry a saw.

*Glen Prosen,
Scotland*

NUNS WERE IN
CARRIAGE, A
HIMSELF ONE
THE OTHER
STROKE

Southampton

I don't pee in your swimming
pool. So please do not swim in
my loo.

gents' lavatory,
Sunningdale

I wish I could drink like a lady
I can take one or two at the most.
Three puts me under the table
And four puts me under the host.
Letchworth

339

*T*his shall be the Rosetta Stone for
the next civilisation, consider
your words well.
New York

IN CASE
MALFUN
MARRY

*D*rinking ******'s beer is like
making love in a boat – it's
fucking close to water.
Birmingham

*I*f you have wet dreams, take
your umbrella to bed with you.
Stockport

I whisper your weight.
> *on weighing*
> *machine,*
> *Dartford*

OF CTION

> *on contraceptive*
> *vending machine,*
> *West Germany*

*T*ypical workman. He promises to plane my door today but he's gadding off to Jerusalem on a donkey.

> *Worksop*

*B*ureaucracy rules OK
> OK
> OK
> *Swansea*

341

WOMEN'S BODIES BELONG
TO THEMSELVES
– I do so agree – but isn't it nice to
share?

ladies' lavatory,
London WC1

Women's libbers should be put
behind bras.

University of
Adelaide

(disc-on-tent)

(H8 = Hate)

visual graffiti
common among
service men,
early 1960s

THIS WALL IS ALSO
AVAILABLE ON CASSETTE
AND CARTRIDGE IN MOST
GOOD RECORD SHOPS

Sowerby Bridge

TO BE A TRIX OR NOT
TO BE A TRIX THAT IS THE
QUESTION

Groningen,
Netherlands,1980

*N*EXT TIME LEAVE THE
CAR AT HOME

> *poster for London*
> *Underground*
> *showing wife and*
> *daughter finding*
> *Tube train in*
> *garage*

– another of his practical jokes.

*I*f girls are made of sugar
and spice, How come they taste
like tuna fish?

> *Seattle*

*D*ON'T LET TURKEY
BECOME ANOTHER CHILE
– make a risotto.

> *Oxford*

*T*wo's company, three's a
deformity.

> *London W1*

*D*og with no legs called
Woodbine. His master took him
out for a drag

> *Bradford*

Q. What's white and slithers across the floor?

A. Come Dancing.

Manchester

FREE SID VICIOUS
– well, I certainly wouldn't pay for him.

Waterloo Station,
London

Who's afraid of Virginia Wade?

Wimbledon
Station

Who's afraid of Virginia Woolf?

found by Edward
Albee on a
lavatory wall and
used by him as
the title of play

THE WAGES OF SIN
IS DEATH
BUT THE HOURS
ARE GOOD

Sheffield

*E*NGLISH CAPITALISTS
OUT!
WALES HAS BEEN SOLD!
– Subject to contract.
North Wales

SUPPOSING THEY GAVE
A WAR- AND NOBODY CAME
New Orleans,
1972

WURLITZER ONE FOR THE MONEY TWO FOR
THE SHOW *Worksop*

*W*ATERSHIP DOWN
– you've read the book, you've
seen the film, now eat the pie!
London EC1

*E*IGHT OUT OF TEN
EXECUTIVES WALK THIS
WAY
Yellow Pages
advertisement
– they should loosen their braces.

I hate Yorkies and I hardly ever
smile.
on back of lorry,
seen in Hendon

*F*EWER DOGS, CLEANER STREETS
– fewer graffiti, cleaner walls.
Canterbury

*P*eople don't die in Eastbourne, they just stand them at bus stops.
Eastbourne

*I*n the stronghold of woman I plan an uprising.
Bury St Edmunds

Q Why do people write 'Fuck the Pope' on toilet walls?
A. Because they can't be bothered to write 'Fuck the Moderator of the General Assembly of the Church of Scotland.
Edinburgh

*Y*ou could go through Governor Reagan's deepest thoughts and not get your ankles wet.
Los Angeles, 1980

Some day my prince will come. However, I'll have nothing to do with it.

ladies' lavatory,
Amherst, Mass.

Q WHAT DO YOU CALL A FISH WITH 2 KNEES? A. A TUNNY FISH.

Edinburgh

The Communist Party of Great Britain (Marxist-Leninist) wishes to apologise for the late arrival of the 1979 workers' revolution.

Bristol
Polytechnic

Normal service will be exhumed as soon as possible.

during
gravediggers'
strike, 1979

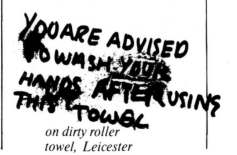

YOU ARE ADVISED TO WASH YOUR HANDS AFTER USING THIS TOWEL

on dirty roller
towel, Leicester

KEEP YOUR NUTS WARM
– NICE ONE SQUIRREL

Worksop

CLOSE ENCOUNTERS
OF THE THIRD KIND
SPECIAL EDITION
NOW THERE IS MORE
DIRECTOR STEVEN
SPIELBERG HAS FILMED
ADDITIONAL SCENES,
DESIGNED TO EXPAND AND
ENHANCE THE ORIGINAL
FILM
– and we still can't understand it!

Turnham Green
Underground
station

If you believe in God, you are
welcome to pray;
If you do not believe in God, you
are welcome to visit;
If you are vain and callous about
the rights and feelings
Of others, write your name on our
walls.

notice at entrance
to Franciscan
church, Mount
Tabor, Israel

Remember – graffiti doesn't
grow on walls.

Barking

FIGHT FOR THE
RIGHT TO PRETEND
TO WORK

Marylebone

I WONDER, O WALL THAT YOU HAVE NOT COLLAPSED UNDER ALL THE WEIGHT OF ALL THE IDIOCIES WITH WHICH THESE IMBECILES COVER YOU.

Pompeii

If Nigel Rees is reading this, I hope I get paid this time.

Cambridge Circus, London

I only wrote this to get on 'Quote…Unquote'.

British Museum

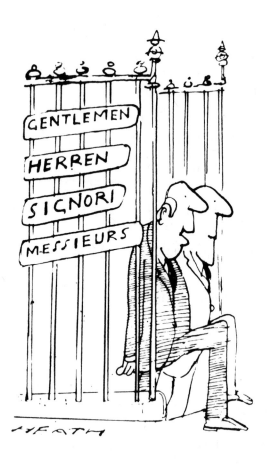

"I suppose it makes a change to see all that foreign graffiti."

The following photographs appear by permission
of the copyright holders,

Roy Reed:

Don't worry
Why is man on this planet

Chris Furby:

Please return my dog
Millwall Brickwall Maxwall!
Women reclaim the Night
Help the Police beat yourself Up
If it were a lady
Whither atrophy?
Guilt is the cop in your head
Love is 3 minutes of squelching noises
Nuclear waste fades your genes
Incest – a game the whole family can play
Hygiene. Please now burn your clothes

Syndication International:

Dads army beware?

Topix:

God save the Queen

Cover photograph: **Tony McSweeney,**
Sunday Times

The following illustrations appear by
permission of the copyright holders:

Apathy Ru **Dredge,** *Punch*
Open the second front now! **Hector Breeze,** *Punch*
Urinal **Heath,** *Private Eye*
Martian **McLachlan,** *Private Eye*
The Fuzz are a load of ... **Noel Ford,** *Syndication International*
Sod the Spurs **Dickinson,** *Punch*

You reached Earth, then? **Deta Nougerede**, *Punch*
A Happy New Year to all our readers **Mahood**, *Punch*
This is going to make … **Plowry**, *Punch*
He's here every week … **Albert**, *Punch*
Teacher is a red **Waite**, *Syndication International*
Gentlemen, Herren, Signori, Messieurs **Heath**, *Punch*
George Davis is innocent **Waite**, *Syndication International*
Hi, I'm Rob … **Plowry**, *Punch*
Down with the USSR **Waite**, *Syndication International*
Goodness knows I've tried … **Hector Breeze**, *Punch*
Have you been waiting long, dear? **Ken Pyne**, *Punch*
Revolution now! **Ken Pyne**, *Punch*
St George Rules OK **K. Alexander**, *Syndication International*
Town FC Rules OK **Waite**, *Syndication International*